IMAGES
of America

BELMAR
VOLUME II

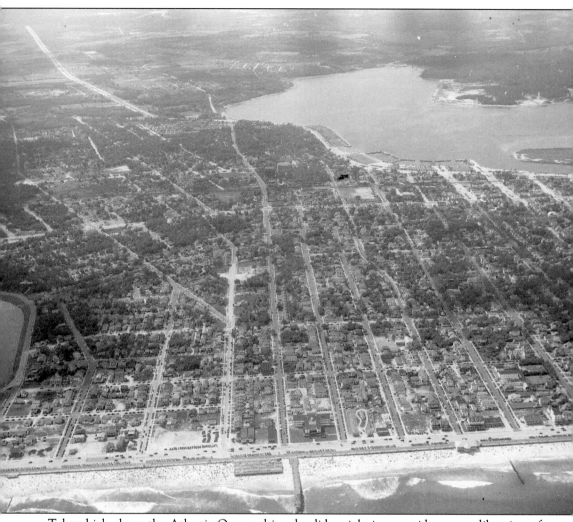

Taken high above the Atlantic Ocean, this splendid aerial view provides a map-like vista of Belmar from Eleventh Avenue on the right to Twentieth Avenue, c. 1940. Clearly discernible are the Thirteenth Avenue Pavilion, now a McDonald's restaurant; the Sixteenth Avenue pier, no longer there; and McCann's Atlantic Hotel, which was on Ocean Avenue between Fifteenth and Sixteenth Avenues. Visible in the background are the Shark River Marine Basin and the Belmar Marina, which was new at the time. In the upper left are Rhode Island Point, the L Street beach, and Highway 35 winding through Wall Township. (Cecil Lear.)

IMAGES
of America

BELMAR
VOLUME II

Karen L. Schnitzspahn
and Sandra G. Epstein

ARCADIA
PUBLISHING

Published by Arcadia Publishing
Charleston, South Carolina

Printed in the United States of America

Library of Congress Catalog Card Number: 2008943378

For all general information contact Arcadia Publishing at:
Telephone 843-853-2070
Fax 843-853-0044
E-mail sales@arcadiapublishing.com
For customer service and orders:
Toll-Free 1-888-313-2665

Visit us on the Internet at www.arcadiapublishing.com

We dedicate this book to Gil Steele,
who operated Steele's Photographic Service in Belmar from the 1940s to the 1960s.
He is now retired, but his documentation through the art of photography
provides a marvelous look back at the people and events in Belmar
from an era that many of us remember, but will soon become the distant past—
as we celebrate the millennium. Thank you, Gil!

Gil Steele in a *c.* 1940s photograph.

CONTENTS

ACKNOWLEDGMENTS

This second volume of Belmar would not have been possible without the support and enthusiasm of the following individuals and businesses whom we are grateful to for taking time to help us with our research. We extend extra special thanks to those who trusted us with their treasured family photographs. The lenders of all photographs are identified either after the captions or within the captions. Those images that are not identified are from the collections of the two authors.

We extend our deepest appreciation to the following individuals, who provided many images and information to accompany them: Claire Angrist, Gail Bram, Arthur C. Fox, M.D., David I. Fox, Lois Gennell, Beverly Kaplan, Carolyn Larson, Cecil and Mary Lou Lear, Frank and Margaret Mihlon, Dick Napoliton, James J. Newberry, Barbara Preising, Gil and Martha Steele, and Robert Watkins Jr.

We would also like to thank the following individuals, each one of them of great importance to this volume, for providing one or several photographs and/or information: Bruce Allen, Bob Brand, Mary Christian, Patricia Colrick, R. Conklin, Mildred Desmond Day, Charlie Dodd, Brian Epstein, Marilyn Fliegler, Lois Gallagher, Jane Gannon, John Gilhooley, Theodora Granoff, Dennis Lewis, Pat McCann Jr., Trish Millines, George H. Moss Jr., Nancy Myers, Sari Raby, John F. Rhody, Robert A. Schoeffling, Virginia Slusser, Suzanne Spencer, David Stanley, Rose Steffen, Mr. and Mrs. John Taylor, Howard Wiener, and Bob Wilkins.

We extend a big thank-you to the f/Stop shop, Your One Stop Photo Shop, located at 908 Main Street, Belmar. We are grateful to f/Stop owner John P. O'Heney Jr., both for his photographic know-how and his kindness to us while we were working on this book.

Thank-you to Tim Harmon of the Boathouse Bar & Grill, The Fisherman's Den at the Belmar Marina, Tom and Rosemary Volker of the Inn at the Shore, Ollie Klein's Fish Market and Waterside Cafe (with special thanks to Michele Klein), David Schatzow, Sterner Lumber, Taylor Hardware, Vesuvio Restaurant & Pizzeria, Waterview Pavilion, and Tom and Linda Wagner of The White House.

Thank-you to the Belmar Department of Tourism and Sharon Day, Richard Reigler of Belmar.com, Belmar Borough Clerk Margaret Plummer, the Belmar Board of Education, the Belmar Public Library, and Monmouth University.

Thanks and many hugs to "Friends & Angels" everywhere!

We are grateful for the love and support of our adult children, Doug and Greg Schnitzspahn and Brian and Doni Epstein. May they enjoy our book for many years to come.

And last, but not least, we thank our husbands, Leon Schnitzspahn and Warren Epstein, for their love, their strength, and their patience!

A PREFACE
By Two Friends

By the sea, by the sea, by the beautiful sea, you and me, you and me, by the beautiful sea!
—from the song by Harold R. Atteridge and Harry Carroll, copyright 1914

There is so much more to Belmar than the beautiful sea, the Shark River, and Silver Lake. There is so much more than all the great shops, amusements, restaurants, and guesthouses. There are the *people* of Belmar—those who come for the summer, those who work here, and those who make Belmar their home all year. This second volume on Belmar provides another enjoyable journey back through the years of the borough that formally began as Ocean Beach in 1872.*

Although images from the 1870s to the 1970s are included, this book is not a chronicle of or a guidebook to Belmar. Nor is it a continuation of the first volume, which also included all those years. It does cover some things that were not in the first book and adds additional photographs and information to some things that were. *Belmar, Volume II* is a nostalgic return to Belmar, a glimpse at the past through the eyes of the people who took the photographs. It is also the continuing story of the town from the perspective of the two authors, who used the materials that became available to them in the time allowed before the publication deadline.

After the publication of *Belmar, Volume I* in 1997, letters gradually streamed in from all across the country, from people who used to live year-round in Belmar and from those who vacationed there. Many of these people offered photographs and information if a second book ever came to be . . . and it has! They enjoyed rekindling their memories of Belmar. If only all their stories could be told! And there are surely many more people out there. It is, of course, impossible to seek out or to include every person who has ever lived in or visited Belmar. The photographs chosen for this volume are but a sampling.

I have made lasting friendships while doing research in Belmar. Many of the people I interviewed have become cherished friends. I wish there were enough space to write a paragraph about each one of them here. Although I have never lived in Belmar, I am not far away, and I have spent a great deal of time in the borough. I chose Belmar as the place to host a very special reunion of friends from all over the United States, which was held in April 1999.

*For more information on the history of Belmar, see the introduction to *Belmar, Volume I* in Arcadia's Images of America series, and Grace Trott Roper's *Belmar in Retrospect,* published in 1978 (available at the Belmar Public Library, Tenth Avenue, Belmar, NJ 07719).

Perhaps the best story of all to evolve from my love of Belmar is the growth of my friendship with coauthor Sandra Granoff Epstein. We met as hospital roommates at Monmouth Medical Center, in Long Branch, New Jersey, in February 1996. It was the winter of a major blizzard and a bleak time, but there is always the healing light that shines and illuminates the way. That light led us to a lasting bond and to *Belmar, Volume II*. I appreciate her diligence and her patience. But besides the work, what fun we have had! Thank you, Sandy.

—*Karen L. Schnitzspahn*
June 1999

As I look back through the past year, working with Karen on *Belmar, Volume II*, "working" is not quite the appropriate word. *Belmar, Volume II* has been a memorable and enjoyable experience in several ways. Having spent my childhood on Eleventh Avenue and B Street, the research has taken me back in time, filled in the years I have been away, and made me look ahead.

After contacting friends and neighbors from my past, I spent many afternoons reminiscing while going through family albums (including my own). I even heard anecdotes about my own family: the wonderful memories of my father, Irving Granoff, my mother, Teddy, and even a funny story about my sister, "Ronnie the girl." Meeting people I didn't know from the past made me realize that Belmar is unique. Families have remained in Belmar for generations, many of them living in the same house or working in the same business as their parents and grandparents and always willing to share their tale.

Of course, all this takes me to the present and on to the future. As the writing of *Belmar, Volume II* comes to a close, I feel sad that spending so many beautiful days (and one rainy day) in Belmar with coauthor Karen Schnitzspahn, researching and sharing Belmar's history, has officially come to an end. However, I know that my friendship with Karen will not end with this book. We have spent endless hours working, laughing, and just talking to each other. Working with Karen, a true professional, has taught me more than I ever imagined possible. Our friendship has grown and become very special to me, and for that, Karen, I thank you.

I hope everyone gets as much pleasure reading *Belmar, Volume II* as we did in creating it!

—*Sandra G. Epstein*
June 1999

Correspondence for the authors may be sent to P.O. Box 716, Red Bank, NJ 07701.

For tourist information, contact the Belmar Tourism Association, P.O. Box 297, Belmar, NJ 07719, or visit Belmar's website on the internet at Belmar.com.

One

A BYGONE ERA BY THE BEAUTIFUL SEA

(1870s–1930s)

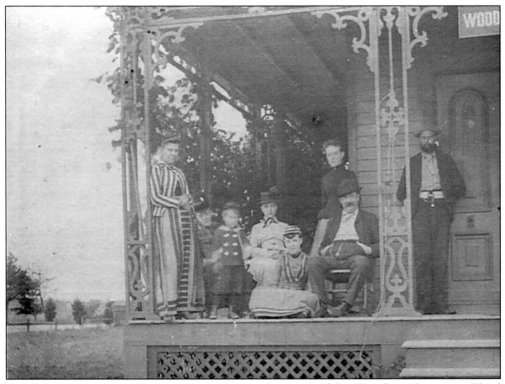

A delightful group of summer visitors relaxes on the porch of the Woodbine Cottage at Third Avenue and B Street. The image is from before 1882, *c.* late 1870s. Belmar was known as Ocean Beach before 1889. Notice the bold stripes on the clothing and the casual poses. (Carolyn Larson.)

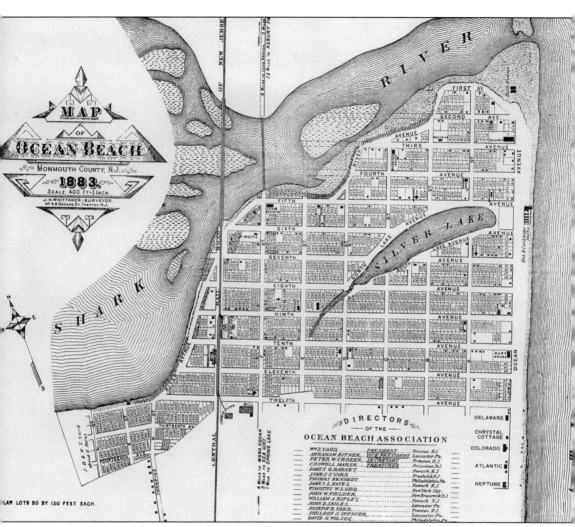

An 1883 map of Ocean Beach lists the names of the directors of the Ocean Beach Association and where they came from. These foresighted men felt that nearby Ocean Grove was getting too crowded and founded the resort that is now Belmar in 1872. The regular 50-by-100-foot lots are numbered on this map, whereas names have replaced numbers on the 1889 map that appears on pp. 14 and 15 of *Belmar, Volume I.* (Virginia Slusser.)

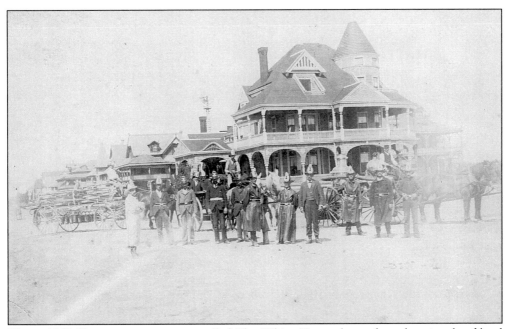

The c. 1888 Victorian cottage now called The White House, located on the triangle of land between First and Second Avenues, is seen here in the late 1890s when it was the private residence of Sanford Ross, Esq. It appears that the Belmar firemen are posing for a photograph, not fighting a fire, as there is no smoke or damage to the structure. According to Tom Wagner, current owner, there was a fire in 1906 that greatly altered the roof, eliminated the tower, and changed the style and appearance of the home. (R. Conklin.)

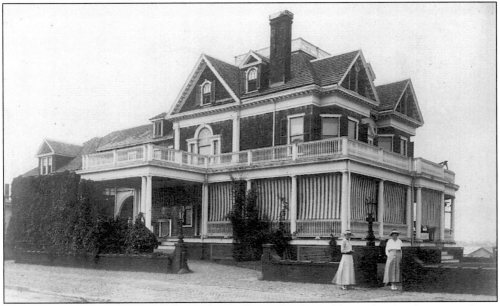

The structural changes, especially to the roof, are clearly visible in this lovely image of two ladies in front of the former Sanford Ross house, c. 1915. The residence became the Cochran House, as depicted on a popular postcard (see p. 30 of *Belmar, Volume I*). On the left, part of the archway that was a pass-through driveway can be seen. (Tom and Linda Wagner.)

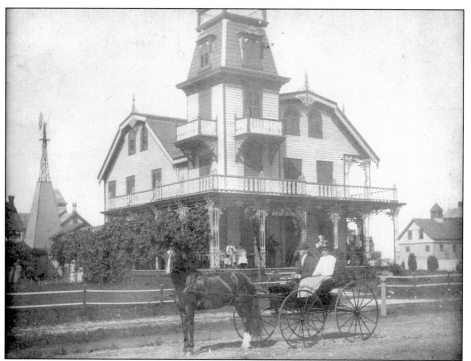

John Roscoe Blackwell Slayback (1871–1956) takes his sister, Lilly Blackwell Slayback (1875–1951), for a carriage ride, c. 1892. They are in front of the Woodbine Cottage, the family's summer home. Notice the windmill on the left. In those pre-automobile days, the journey from the Slayback home in Princeton to Belmar took all day. On the way, the family always stopped at the Manalapan Inn, on the northwest corner of Routes 33 and 527-Alternate, to rest and water the horse. (Carolyn Larson.)

This card was from the postcard series Greetings from Picturesque America (as indicated in the patriotic rendering in the upper right corner), by Arthur Livingston, Publisher, New York. Postmarked 1904, it helps to establish the location of a guesthouse called the Cedars. On p. 30 of *Belmar, Volume I*, the Cedars was mistakenly identified as originally being the Woodbine Cottage. The Cedars was at Third Avenue and C Street.

The clapboards and rustic fence provide clues that this image of the Woodbine Cottage's east side dates from the late 19th century. Also, at the rear of the house is an addition called the Laundry, built c. 1890, where the washing was done on the first floor and maids slept upstairs. The parcel on Third Avenue included four lots on the plan of the Ocean Beach Association and a house built in the 1870s. The property was sold by Isaac Henderson to the Slayback family for about $6,000 on April 27, 1882. John R.B. Slayback also purchased all of Isaac Henderson's furniture, according to a receipt dated May 1, 1882. (Carolyn Larson.)

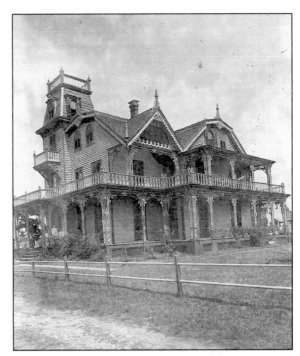

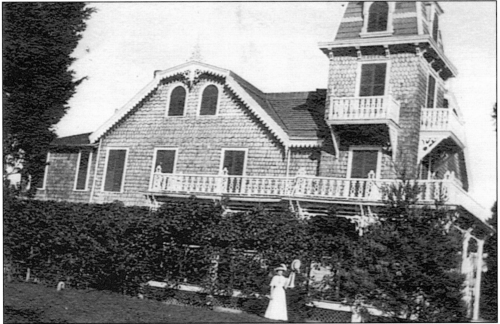

This view reveals the less-photographed west side of the Woodbine Cottage, c. 1910, with vines blanketing the porch. The clapboards have now been replaced by shingles. Standing by the house are Myrtle Slayback Johnson and her husband, Ralph Johnson, of Ocean Grove. Camera shy, he holds his straw boater in front of his face. The back wing of the house included the kitchen on the first floor, toilets on the second, and a grape arbor on the north side of the porch. The house was damaged by fire in the late 1920s and was eventually demolished. (Carolyn Larson.)

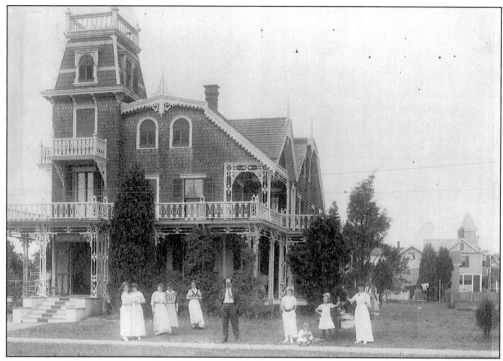

This portrait is another splendid image of the Woodbine Cottage and its inhabitants, *c.* 1911–12. Located at Third Avenue and B Street, the Victorian cottage now has shingles replacing the clapboards, but the gingerbread trim remains much the same as in earlier photographs. The man in the center is Louis Clayton "Woody" Woodruff. Next to Woody, on the right side of the photograph, are, from left to right, Mae Duryea, John Roscoe "Jack" Blackwell Slayback Jr. (with a dog named Teddy), Emily Louise Slayback, and Lilly Blackwell Slayback. (Carolyn Larson.)

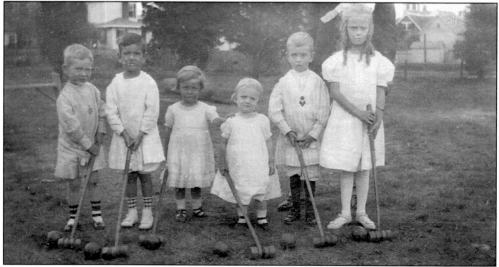

This dedicated-looking group of young athletes has been appropriately dubbed the Woodbine Cottage Croquet Team by Carolyn Larson, owner of the family photograph. The three children, from center to right, are Sherman, Jack, and Emily Slayback.

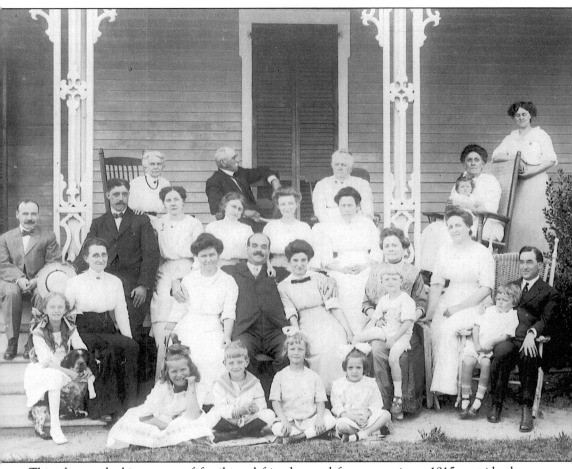

This pleasant-looking group of family and friends posed for a portrait, *c.* 1915, outside the Woodbine Cottage at Third Avenue and B Street. Individuals identified by photograph owner Carolyn Larson include her mother, Emily Louise Slayback (the little girl seated on the far left holding a dog named Spotty); Alice Blackwell Titus (sitting next to Emily); and Carolyn's great-aunt, Lilly Slayback (sitting next to Alice, with Woody's arm around her). Woody Woodruff, the man in the center with his arms around Lilly Slayback and another lovely lady, was Lilly's beau for 30 years. The young boy sitting on a woman's lap is one of Carolyn's uncles, Sherman Lawrence Slayback. Next to him, to the right, is Carolyn's grandmother, Retta Warren Slayback. Another of Carolyn's uncles, John Roscoe "Jack" Blackwell Slayback Jr., is the boy seated on the ground in the front row. The two women behind Woody's head are probably May and Katie Titus. Woody, a Princeton University Class of 1899 graduate, enjoyed going up into the tower of the Woodbine Cottage during storms so he could watch, just for a thrill.

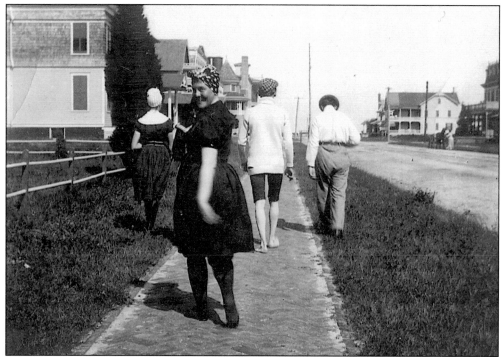

The images on this page are casual snapshots that provide a glimpse of what life was really like visiting Belmar in the good old days. Everything was not so formal as it may appear in posed portraits. Some beach goers, seen here in front of the Woodbine Cottage, are walking east on Third Avenue. An unidentified young woman turns around to smile at the photographer, while Lilly Blackwell Slayback walks ahead with her barefooted brother, John R.B. Slayback, and her beau, Woody Woodruff, wearing long pants. (Carolyn Larson.)

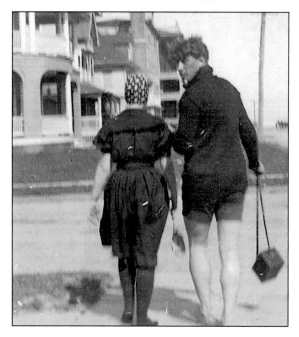

A block closer to the ocean than the above photograph, at Third Avenue and A Street, someone snaps another photograph from the rear. We see the back of the same unidentified young woman as above, but now she is with a barefooted man who is holding a box camera. Perhaps he took the photograph above, and then another person with a camera sneaked up behind him and took a similar shot. (Carolyn Larson.)

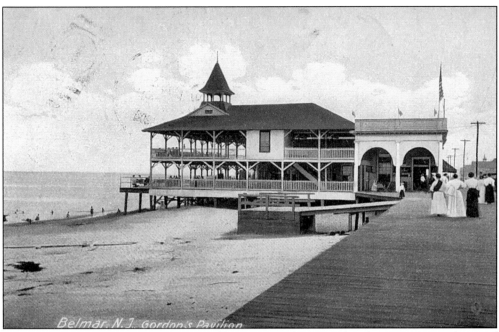

The north side of Gordon's Pavilion at Fifth Avenue is shown in this charming postcard view of German manufacture, dated 1908. (Patricia F. Colrick.)

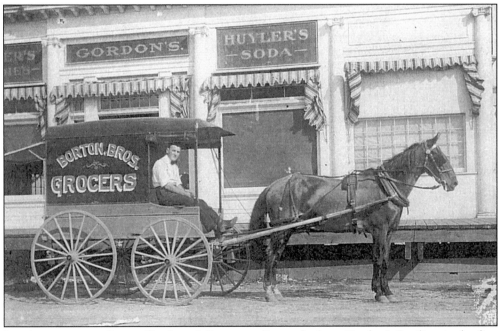

Local grocery store Borton Brothers delivers supplies to the busy Gordon's Pavilion in the first decade of the 20th century, when horses were still the most reliable and most economic means of transportation. (Dick Napoliton.)

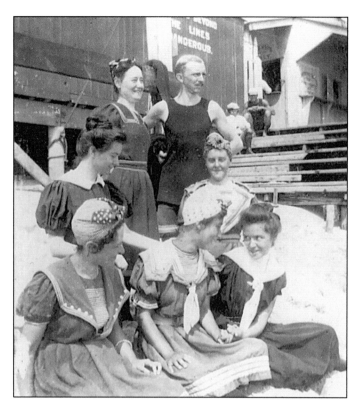

Bathers are relishing the beach by Gordon's Pavilion at Fifth Avenue in the early 1900s. The middy-style bathing costume was obviously fashionable. The lone gentleman in the photograph, John R.B. Slayback, wears a bathing top, as was required for men until the 1940s. (Carolyn Larson.)

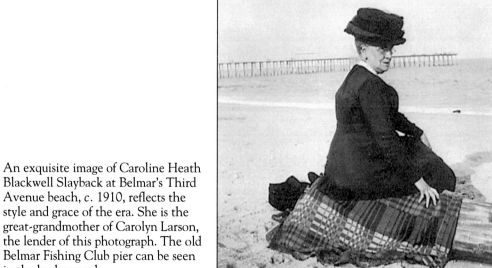

An exquisite image of Caroline Heath Blackwell Slayback at Belmar's Third Avenue beach, c. 1910, reflects the style and grace of the era. She is the great-grandmother of Carolyn Larson, the lender of this photograph. The old Belmar Fishing Club pier can be seen in the background.

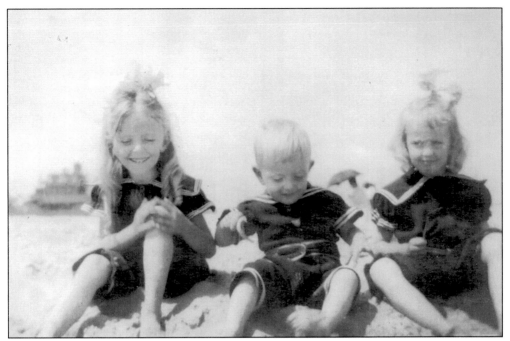

The adorable faces of these children at the beach c. 1909 are timeless. Except for their outmoded bathing costumes, they could be from almost any period. Despite the advent of computers and video games, children today enjoy many of the same summer activities as these children did long ago. From left to right, they are Carolyn Blackwell Slayback, John Roscoe "Jack" Blackwell Slayback Jr., who is playing with a clam shell, and Emily Louise Slayback. (Carolyn Larson.)

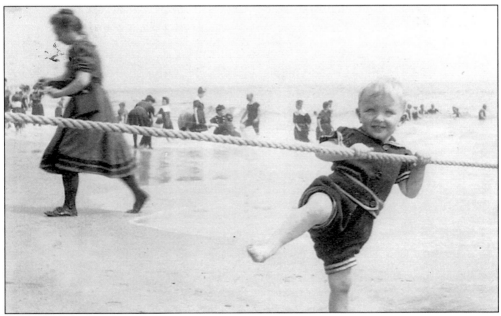

Little Carolyn Blackwell Slayback holds on to the safety ropes and demonstrates a playful kick at the beach by Gordon's Pavilion at Fifth Avenue, c. 1904. (Carolyn Larson.)

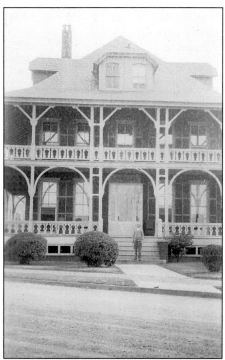

In 1929, Morris Fox stands in front of his family's summer home at 100 First Avenue. The Fox family purchased the house, with its ocean view and floor to ceiling windows that provided natural air-conditioning, from a Captain Wheeler in 1922. Originally built in 1887, the charming home was destroyed by fire about 20 years ago. The garage still stands, but the lot is otherwise vacant. (Arthur C. Fox.)

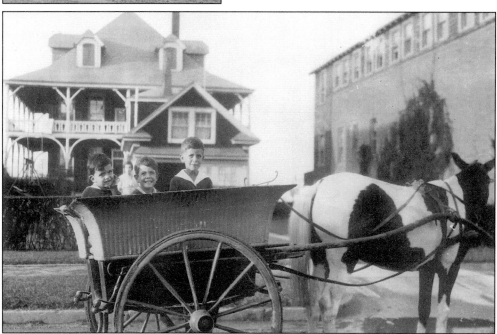

"Giddyup horsie!" Whether or not they went for a ride, brothers Richard, Arthur, and Martin Fox appear happy to pose for their portrait in this pony cart, c. 1930. Facing Second Avenue, they are in the back of their family's summer home at 100 First Avenue. Arthur Fox, who provided this adorable image, remembers how the gravel streets were regularly leveled by Belmar's grader until they were paved in the 1940s. He also recalls that the children often used the pebbles from the roads as "missiles."

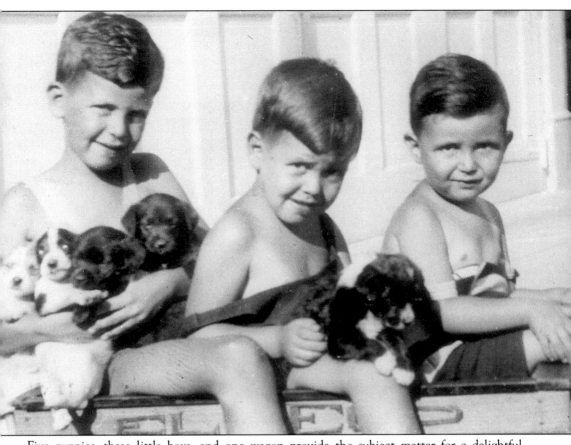

Five puppies, three little boys, and one wagon provide the subject matter for a delightful photograph from 1930. Here are, from left to right, Martin, Arthur, and Richard Fox, the same three brothers in the pony cart shown on the previous page. According to Arthur, "The puppies were the contribution of a prolific lady of mixed breed named Fritzi. She once had a litter of eight in the backseat of my father's 1928 Lincoln as we were driving home to Newark from Belmar." Arthur wrote this poem, which brings back childhood memories of happy summers spent "down the shore."

Race across the white hot sand
Save your soles by jumping on your towel
Or cower in the footprints left
By other sprinters to the cooler boardwalk
With its lurking threat of—SPLINTERS!
LOOK BOTH WAYS!
Then dash across the seared concrete of Ocean Avenue.
Whew, The sidewalk bricks are hot.
Tiptoe, or on your heels along
The crabgrass on the sides
(Sometimes prickly),
Quickly, then into the yard,
Our own cool, sprinkled grassy bower,
And then at last the faucet and the shower.
GET OUT OF THOSE WET BATHING CLOTHES
AND WASH THAT SAND OFF WITH THE HOSE.

In 1923, Jack Fox brought his bride, Mae, to his family summer home at 100 First Avenue. Then the newlyweds took a honeymoon trip by train from Quebec to the Canadian Rockies and drove by car down the West Coast. Jack's other love affair, besides his lovely wife, who was once Miss Newark, was with the automobile. Jack and Mae, seen here at the Belmar Beach in the early 1920s, had four sons: Richard, Arthur, Martin, and David. The family spent many happy summers at Belmar. Jack lived to be 95 and Mae to be 88. (Arthur C. Fox.)

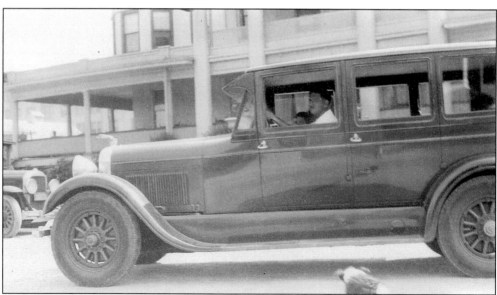

Jack Fox enjoys being behind the wheel of his Lincoln in the late 1920s with one of his sons. The Buena Vista Hotel on Second Avenue, which was directly behind the Fox family's rear garage and driveway, is in the background. The family dog, Fritzi, mother of the five puppies on the previous page—plus another 81 during her lifetime—is visible in the foreground. (David I. Fox.)

Attorney Jack Fox tries to relax and read his newspaper on Belmar's Second Avenue beach in the 1920s, but his son Martin has other ideas. It was the summer of 1929, just before the autumn stock market crash that devastated the nation. (Arthur C. Fox.)

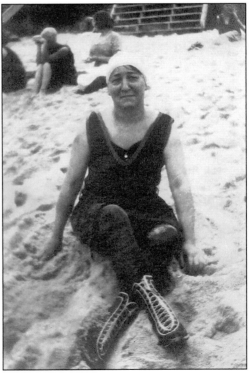

Wearing what were chic bathing costumes in 1918, these two Belmar beauties are the mother and grandmother of Cecil Lear. Lear, a well-known Belmar resident and lifeguard for many years, loaned these treasured family photographs. On the left is Eleanor Bauder (Lear) at age 17 and on the right is her mother, Anna Bauder.

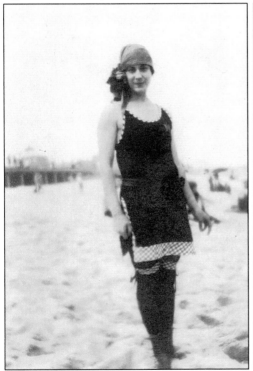

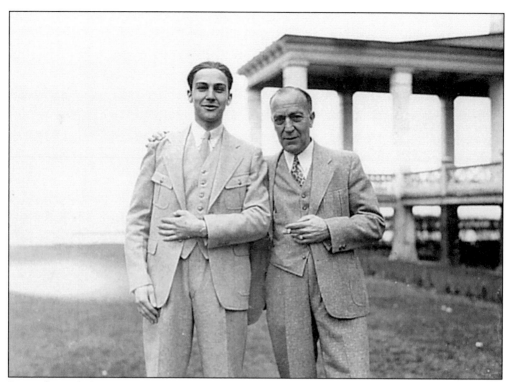

Dressed in stylish tweed suits with vests, Frank Mihlon Jr. and his father, Frank Sr., stand proudly on the side yard of their Ocean Avenue home in 1935. The porch of the New Columbia Hotel on Third Avenue is visible in the background. (Frank Mihlon Jr.)

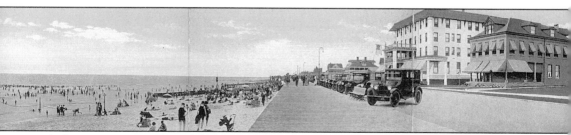

A three-section panoramic foldout postcard, c. 1930s, shows the Mihlon house at the far right with striped awnings. The impressive structure, built in 1882, later became the summer home of Edward C. Stokes, who served for several years as governor of New Jersey. The large white building is the New Columbia Hotel, one of the grandest hotels at the Jersey Shore. The New Columbia was destroyed by fire in 1939. (Frank Mihlon Jr.)

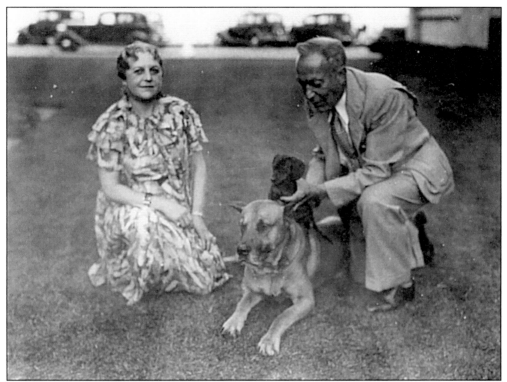

In 1935, Frank Mihlon Sr. frolics with the family dogs, a Great Dane named Ralph and a Dachshund called Koenig, while Minnie Mihlon looks on. Automobiles parked on Ocean Avenue in front of the Mihlon home can be seen in the background. Minnie was a former star of silent films, and Frank was a famous sports promoter and the benefactor responsible for the Belmar First Aid Squad's original ambulance (see *Belmar, Volume I*, p. 72). (Frank Mihlon Jr.)

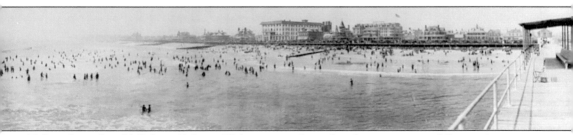

Taken from the old Belmar Fishing Club pier, on the right, this panorama of Ocean Avenue *c.* 1920s was captured by Adams & Brown, Asbury Park photographers who produced a series of views in this format. The large white building at the center of the image is the New Columbia Hotel at Ocean and Third Avenues, where apartments are now. Also visible is the Buena Vista Hotel on Second Avenue, which was torn down in the 1960s. (Frank Mihlon Jr.)

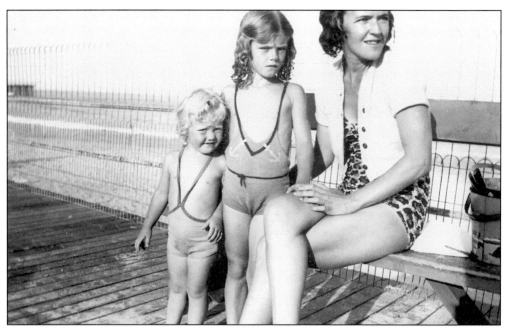

In August 1938, Maude Terhune sits on a bench at the Belmar boardwalk. Next to her are her daughters Barby (left) and Patty. Barby is now Barbara Preising, the lender of this photograph. On the bench at the right is the children's metal sand pail, an ordinary toy of yesteryear, made by the Chein Company, which has now become a collectible. The Terhune family lived year-round on Eleventh Avenue.

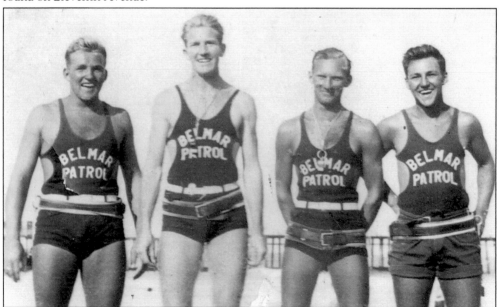

Members of the Belmar Patrol, from left to right, Don Schnable, Bob Moore, Milt Schneider, and Syl DiStasio, appear ready to face the crowded beaches that they protected during the 1930s. Prior to the 1940s, lifeguards were required to wear tops, which were attached to their trunks with zippers. According to former Belmar lifeguard Bob Watkins, the woolen bathing suits were itchy and very heavy when wet. (Boathouse Bar & Grill.)

Two

FUN AT THE BELMAR BEACH
(1940s–1950s)

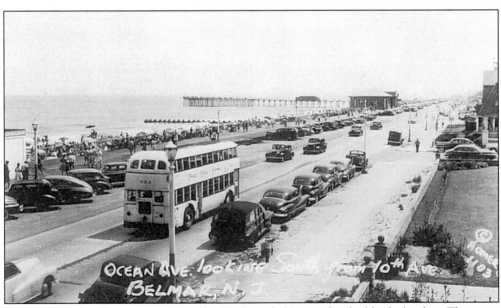

OCEAN AVE. looking South from 10th Ave.
BELMAR, N. J.

A popular mode of transportation in the 1940s and '50s was the double-decker bus. The route along Ocean Avenue was scenic, especially from the upper deck. With a cool breeze coming from the ocean, it created a very relaxing ride. This postcard view, looking south from Tenth Avenue, shows the Thirteenth Avenue Pavilion in the distance. (Dick Napoliton.)

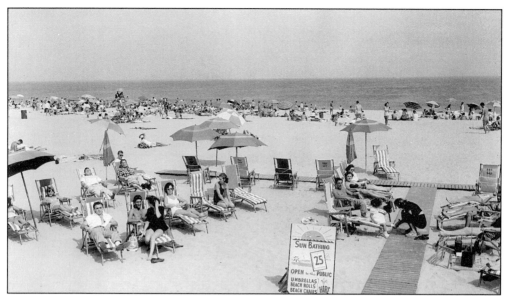

Sun worshipers enjoy a peaceful day at the beach in this late 1940s picture. On the left, in the background, the lifeguards can be seen on the guard bench above the crowd, watching for swimmers in distress and signaling by whistle when the tide comes in. A mother helps her little girl with her shoe. Sunbathers take advantage of the 25¢-an-hour umbrella and chair rental—a real bargain! (Steele's Photographic Service.)

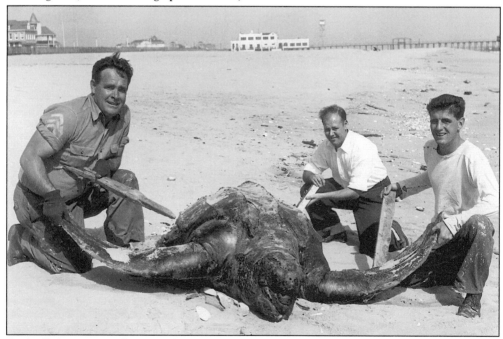

With all the creatures living in the ocean, it is always a surprise to see what might wash ashore. These three men are trying to find a way to dispose of this unfortunate sea turtle. Shown here in the 1950s, from left to right, are an unidentified man, Seymour Granoff, and Bob Pringle. The fishing pier and the Shark River Coast Guard tower are visible in the background. (Steele's Photographic Service.)

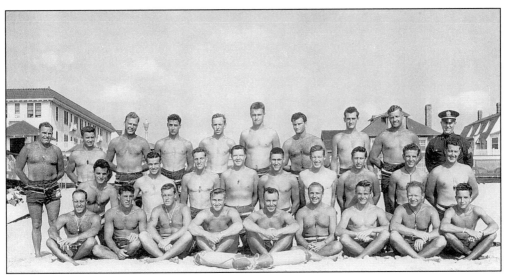

Bathers could always feel secure in the water when they were under the watchful eyes of the Belmar lifeguards. The lifeguards in this late 1940s picture are, from left to right, as follows: (front row) Dick Cardasco, Emil Gennell, Bob Crosta, Bill Eggimann, Bob Watkins, Jim Russo, Bob Clancy, Ray Darby, and Jack Canning; (middle row) Gene Scanzera, Carl Weidel, Marshall Davenport, Brant Clark, Jerry Britting, Red Williams, Bob McEntee, Bob Pringle, and Jack Redmond; (back row) Howard Rowland (captain), Art Bauer, Dick Seuffert, Bill Dioguardi, Don Kleinkof, Bill Wilson, Joe Kirschenbaum, Henry McArdle, Bud Hamill, and Bill Briden (sergeant). (Bob Watkins Jr.)

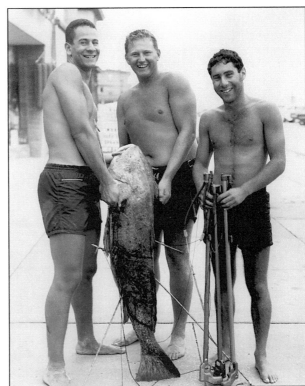

Three Belmar lifeguards show off their catch, a red drum they caught spearfishing off the beach. In this July 1957 picture, Les Reitman, John Baez, and Burt Frank are all smiles. (Steele's Photographic Service.)

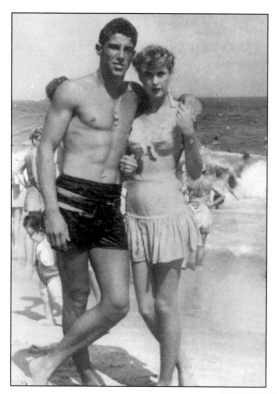

Lois Adams Gennell and Emil Gennell proved that summer romances can last: in 1995, they celebrated their 50th wedding anniversary. This 1945 photograph of the handsome Belmar lifeguard Emil and the lovely bathing beauty Lois is a treasure belonging to Lois, who kindly loaned it for this volume. The couple met at one of the dances, fondly called the rat races, that were held at the Fifth Avenue Pavilion during the 1940s. Emil, who passed away in 1996, protected the Tenth Avenue Beach from 1943 to 1948.

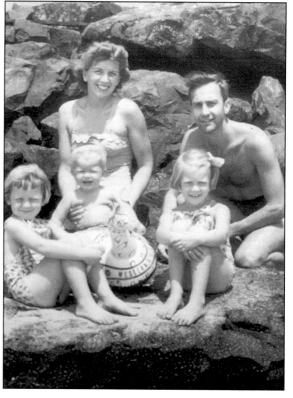

"Mihlons on the Rocks" might be an appropriate title for this c. 1953 portrait. Sitting on the rocks near the inlet, a favorite place for photograph sessions, are Belmar's Margaret and Frank Mihlon Jr. with their children, from left to right, Merilee (now Anderson), Frank Mihlon III, and Marlene (now Reddington). (Photograph courtesy of the Mihlon family.)

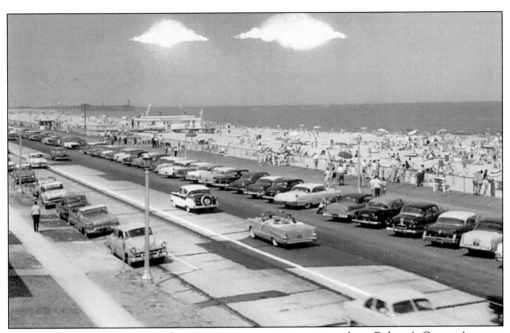

In those fabulous fifties, a popular summer pastime was cruising along Belmar's Ocean Avenue, as depicted in this postcard view from that era. These now classic cars bring back many happy memories.

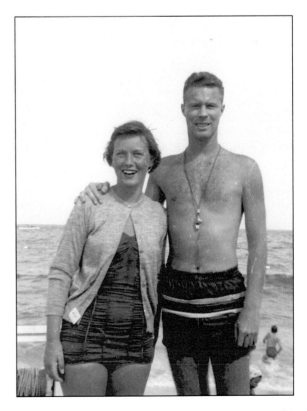

A rainy Memorial Day in 1953 did have some bright spots. If were not for the rain, Mary Lou Mervin and Cecil Lear's paths might never have crossed. Cecil, a Belmar lifeguard, was standing on the boardwalk in the rain when fellow lifeguards noticed several young ladies on bicycles. One of the lifeguards had his eye on the girl with a ponytail, and Cecil's eye went to Mary Lou. Longtime Belmar residents Cecil and Mary Lou Lear still have eyes for each other 46 years later. (Cecil Lear.)

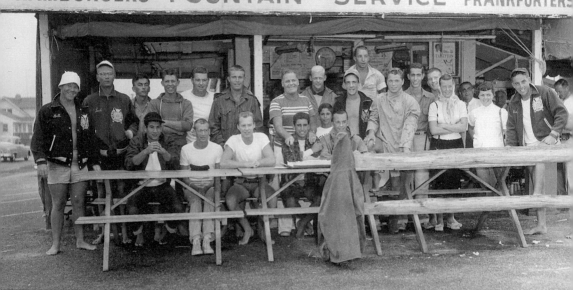

Former lifeguard Cecil Lear recently identified many of the people attending Howard Rowland's annual August birthday party at Sidoroff's on Ocean and Nineteenth Avenues. In this 1953 picture, Howard is standing in the center, wearing a striped shirt—one of the few pictures of Howard not in uniform—his bathing suit. Celebrating with Howard are, from left to right, as follows: (seated) Les Reitman, Irwin Hyman, Frank Nigel, unidentified, unidentified, and Don Graham; (standing) Bill Briden, Frank ?, Marty Ryan, unidentified, Jack Davis, Harry Foerst, Chris Desmond, Dixie Walker, Howard Wiener, George Wilson, unidentified, George Marron, unidentified, unidentified, Mary Lou Mervin Lear, unidentified, Joan Davis, unidentified, Dutch White, unidentified, and unidentified. Known as "Mr. Water Safety," Howard Rowland is a local lifeguard legend. Captain of the Belmar lifeguards, he patrolled Belmar's beaches for 54 years. He was tough, but only because he cared. His guards had to pass an extremely difficult swim test, and it did not end there. He encouraged lifeguard tournaments to promote competition among the guards. As tough as he was, lifeguards loved working for him. He first introduced Monmouth County to the torpedo rescue buoy known the "torp," which made rescue conditions easier for the guards. The torp is on display at the Boathouse Bar and Grill. According to former lifeguard Bob Watkins, "It was an honor to work for Howard. It was even a big deal to work for him preseason for the salary of a hot dog and a root beer." During his lifetime, Howard derived great pleasure from teaching thousands of people, especially children, to swim; and he refused to accept money for the lessons he gave. He would randomly appear at a pool in the area and give lessons to everyone willing to learn. One more swimmer meant that one more life might be saved one day, and that was enough payment for him. Howard was the recipient of numerous citations commending his public service, including one from the National Foundation for Polio, thanking him for his services in rehabilitating polio victims by teaching them to swim. In recent years, one of Belmar's tributes to Howard was renaming the Tenth Avenue Pavilion the Howard Rowland Pavilion. Howard was always telling the guards that he would come back one day as a sea gull; the guards still look for a signal and wonder if one of the gulls is Howard watching over the Belmar beaches. (Howard Wiener.)

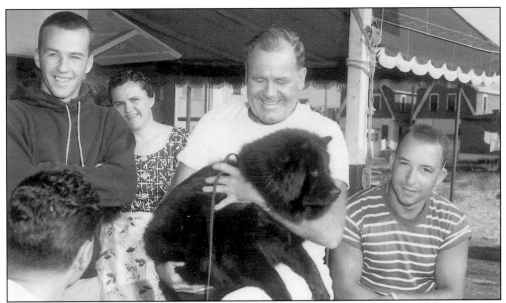

Standing in front of Sidoroff's in the early 1950s, Howard Rowland shows off his birthday present from the lifeguards. Ming, Howard's beloved black Chow, had died, and the guards knew how much he missed his pet. They secretly searched everywhere until they found another dog that looked exactly like Ming. It is obvious from his smile that Howard loved his present. Surrounding the dog, from left to right, are Donny Graham; Natasha Skuby, Sideroff's daughter in law; Howard Rowland; and Howard Wiener (see p. 43 of *Belmar, Volume I*). (Howard Wiener.)

There is always time to monkey around, but not when you are on duty. Ray Darby, an unidentified honorary lifeguard, and Howard Rowland take time out to smile for this photograph, c. 1962. The chimp liked his lifeguard status so much that he attended many of the guard functions during the summer. When asked what he remembered about the chimp, former lifeguard Ken Cassie said, "He was not a very nice chimp." He liked to attack humans. (Boathouse Bar and Grill.)

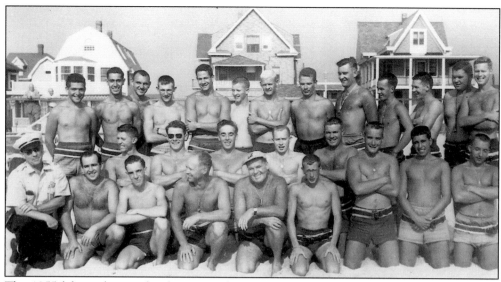

The 1955 lifeguards pose for their annual picture on Tenth Avenue. The are, from left to right, as follows: (front row) William Briden (sergeant), Paul Pollak, Dixie Dugan, Ray Darby (assistant captain), Howard Rowland (captain), and Irwin Hyman; (middle row) Ray Streleki, Ronnie Bizzoso, unidentified, and Howard Wiener; (back row) Roger Obendorf, unidentified, Fred Bretz, George Harlander, Les Reitman, George Marron, Chris Desmond, unidentified, Walt Litowinsky, Don Graham, unidentified, Jack Davis, and Cecil Lear. (Boathouse Bar and Grill.)

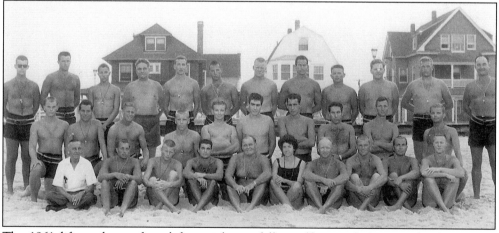

The 1961 lifeguards are, from left to right, as follows: (first row) George Kleinkof (beach director), unidentified, Jim Wardell, unidentified, Howard Rowland (captain), Suzanne Kaufer, Ray Darby Sr., Ben Lindsley, Charlie Zois, and Cecil Lear; (middle row) Doug Quelch, Ed Shur, unidentified, unidentified, Ray Darby Jr., Joe Davidson, Tony Ciansi, Bert Frank, Ken Cassie, and Marty Reich; (back row) Jack McCarthy, Ray Streleki, Chris Zois, Sid Kaufer, Dave Laird, ? Frankel, Joe Semus, Les Reitman, Joel Poplar, Jack Baetz, Terry McGovern, and Frank Brook. Ray Streleki was struck and killed by lightening while in the line of duty. Pharmacist Sid Kaufer, a friend of Howard's, combined calamine lotion and zinc oxide, which Howard promoted, to prevent cracked lips and peeling noses on the lifeguards. If you were lucky to know Howard, he was always willing to give you a jar of his cream, which he named Klik. (Suzanne Kaufer Spencer.)

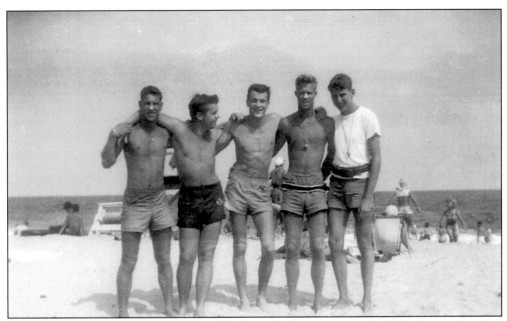

These handsome young men, known as "the boys," strike a pose on the Fifth Avenue beach in August 1949. They are, from left to right, Don Thixton, Jim Walker, John Mayer, Cecil Lear, and Dick Bonk. Cecil is wearing a white lotion on his nose—could that be Howard Rowland's Klik? (Cecil Lear.)

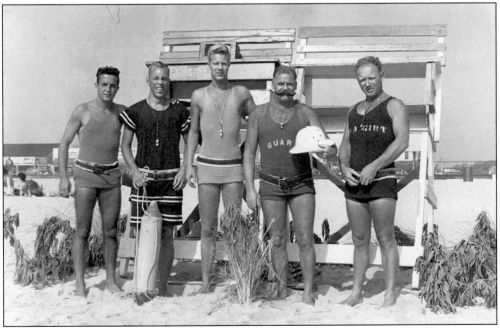

Labor Day and it is the end of another summer. Posing in heavy, itchy, wool bathing suits for the annual Labor Day dress up are, from left to right, Jack Canning, Jake Peppers, Cecil Lear, Howard Rowland, and Ray Darby Sr. Notice the black grass, taken from under the fishing pier and planted around the lifeguard stand to dress it up. This 1950 picture was taken on the Fifth Avenue beach. (Cecil Lear.)

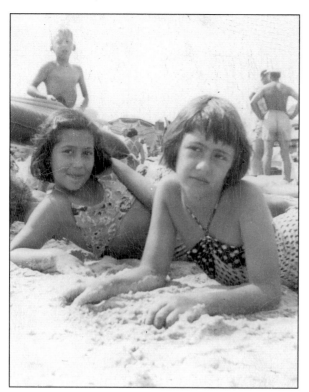

Bathing beauties Beverly Weinstein and Sandra Granoff are taking in all the sun they can get on a beautiful July day in 1950. The two Belmar natives and best friends spent many summers on the Tenth and Eleventh Avenue beaches laughing, talking, building sand castles, and posing for pictures. (Beverly Weinstein Kaplan.)

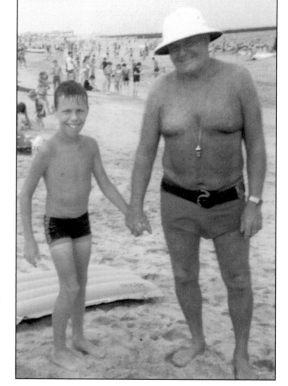

In August 1969, Howard Rowland and Bob Watkins III walk hand in hand along the beach. Children loved Howard and often he would be seen both walking and laughing with them or holding the hand of a crying child while searching for a lost parent. (Bob Watkins Jr.)

Three

FOOD AND LODGING

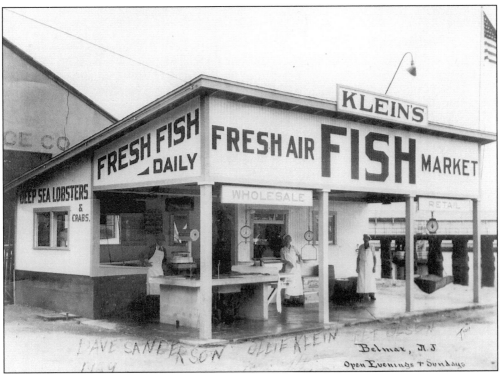

In 1929, Ollie Klein Sr. opened this breezy open-air seafood market at 708 River Road, after peddling fish from his truck since 1924 and then operating a store in 1928 at Captain Kidd's Landing on Fifth Avenue. From left to right are Dave Sanderson, Ollie Klein Sr., and Pete Olsen. Sanderson soon left Klein's and decided to go into business for himself. With Evelyn Longstreet, he opened The Original Dave and Evelyn's Seafood nearby (see p. 44). Today, Ollie Klein's establishment, greatly modernized and expanded, is the home of Klein's Fish Market and Waterside Cafe. (Klein's Fish Market.)

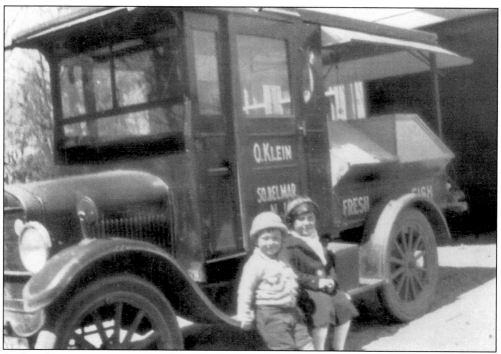

In this charming 1927 image, Ollie Klein Jr. and his sister Jeanette (DeRoche) enjoy sitting on the running board of their dad's truck. Ollie Klein Sr. peddled fish throughout Asbury Park, Ocean Grove, and the Neptune area from this truck during the years 1924 to 1928. (Klein's Fish Market.)

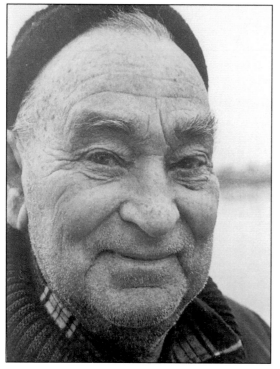

The expressive, weathered face in this wonderful 1968 portrait belongs to Ollie Klein Sr. He was the first of three generations of Kleins to keep the family fish market and restaurant business thriving. (Klein's Fish Market.)

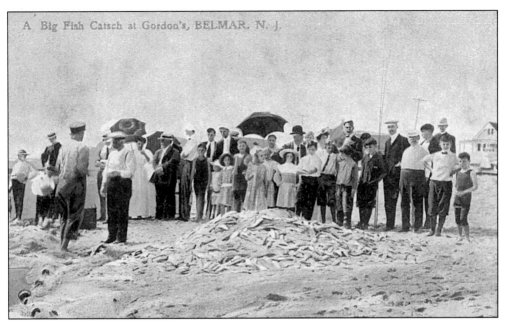

A Big Fish Catsch at Gordon's, BELMAR, N. J.

The well-dressed people in this postcard view from 1909 are looking at a large pile of weakfish, perhaps hoping to have some for dinner. The caption on the card says, "A Big Fish Catsch [sic] at Gordon's Belmar, NJ." Fishing nets can be seen on the beach at the left. Net fishing is a controversial issue today because it is not selective and endangered species may become entangled.

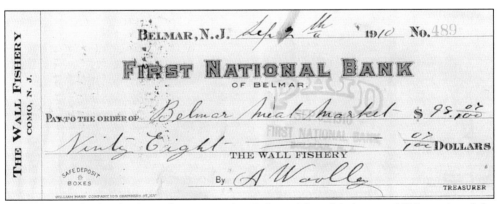

This Belmar bank check made out to the Belmar Meat Market in 1910 is signed by A. (Augustus "Gus") Woolley, who owned the Wall Fishery (see p. 54 of Belmar, Volume I). (Dick Napoliton.)

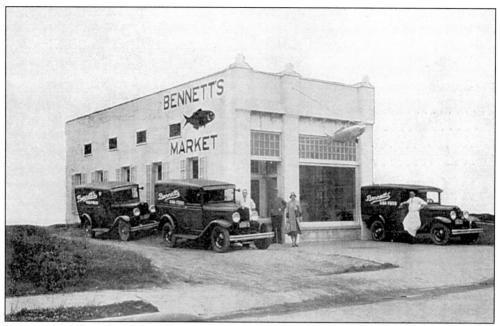

Bennett's Fish Market is advertised on an unusual foldout postcard, c. 1920s. In this photograph on the front of the card, two employees and apparently two customers stand outside with the delivery fleet. A figural image of a fish hangs above the front window of the store, located at 701 Eighth Avenue. (John F. Rhody.)

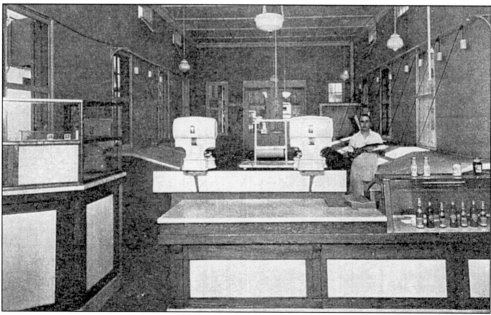

When opened, the inside of the foldout card (see above) reveals a photograph of the interior of Bennett's Fish Market. The motto of the pristine-looking market is, "Why pay more when you cannot buy better?" The ad also says "No frozen fish. Everything fresh from our boats or the nets off our beach." (John F. Rhody.)

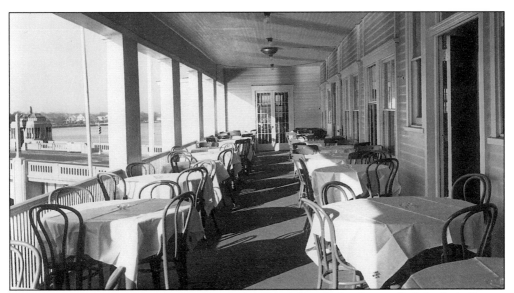

The place to meet and eat was on the deck of the The Deck! Originally Murphy's Casino in the early years of the 20th century (depicted on pp. 82–83 of *Belmar, Volume I*) and later known as Dudley's, the restaurant was on the banks of the Shark River and the F Street bridge. The building was destroyed by fire on Labor Day, 1963, the same day as the terrible fire that destroyed the Tenth Avenue Pavilion. The bridge can be seen on the left side of this *c.* 1940s photo. (Steele's Photographic Service.)

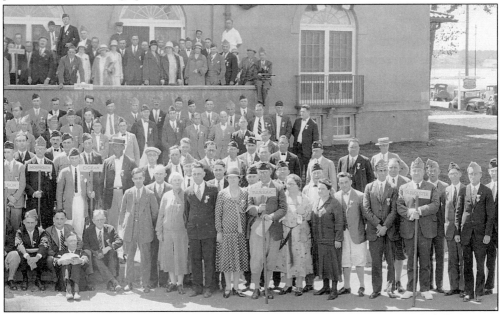

In 1926, New Jersey legionnaires assembled at the American Legion post at Eighth Avenue and River Road. This is the right side, about one third of a huge panoramic photograph. The Monmouth County delegation is seen on the left. In the 1920s, a restaurant run by this post was open to the public and served delicious soft-shelled crab dinners. (For more about this building, now the Waterview Pavilion, see p. 42.) In the upper right corner, the Shark River Basin is visible before the area was filled in for the present marina, *c.* late 1930s. (Patricia F. Colrick.)

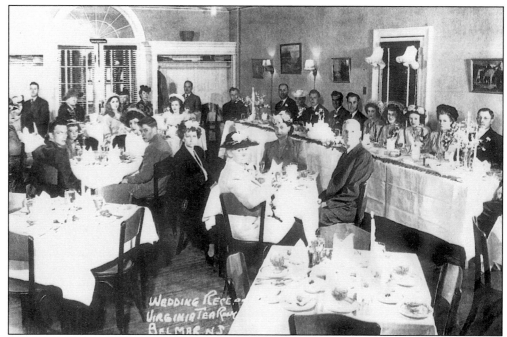

The guests at this 1946 wedding reception look rather solemn. The event was held at the Virginia Tea Room on Route 35 and Eighth Avenue, once the site of the American Legion Home of the Herbert-Worthington-White Post 151. When the American Legion could no longer afford the upkeep, they sold the building to the borough of Belmar for $1. The Spanish-style building then became the home of the Belmar municipal offices, and the borough leased space to the Virginia Tea Room. (Waterview Pavilion.)

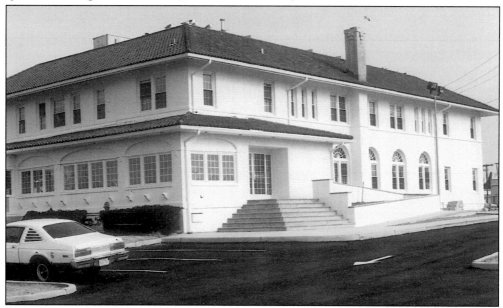

This is a modern view of the building described in the caption at the top of this page and on the bottom of p. 41. The site is now the Waterview Pavilion, a modern banquet facility. (Waterview Pavilion.)

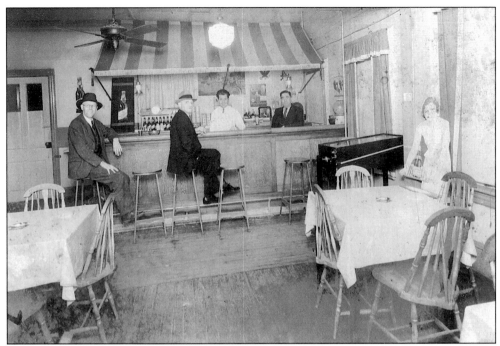

Lou Silverstein, on the right, stands behind the bar chatting with customers at Lou's Bar and Grill in this May 1933 photograph. There is no need for patrons to tip the pretty waitress on the far right—she is a life-sized cardboard cutout. (Gail Silverstein Bram.)

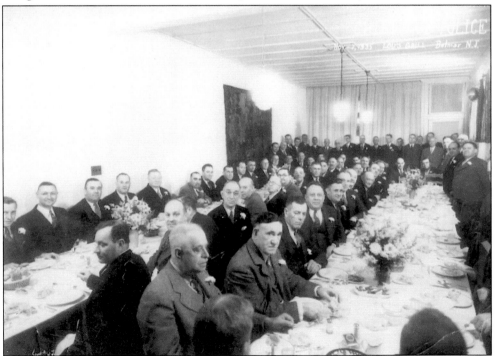

This banquet for local chiefs of police was held in 1933 at Lou's Bar and Grill. (Gail Silverstein Bram.)

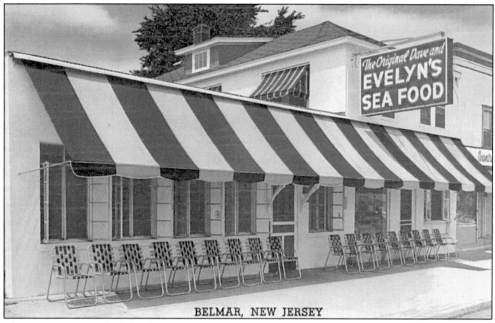

This 1950s postcard of the front of The Original Dave and Evelyn's Seafood must have been taken at a time when the establishment was closed or in the off hours, as those lawn chairs would otherwise be filled with hungry, waiting customers. The well-known restaurant was located on the west side of F Street and Fifth Avenue, near the bridge. Amici's restaurant, which opened in 1999, is at this location today.

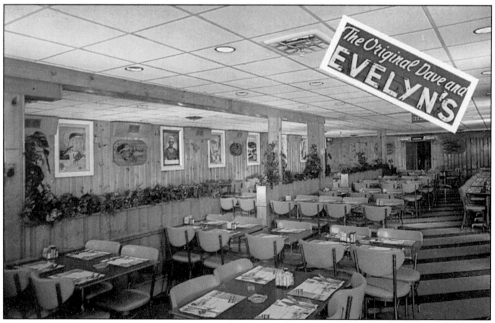

A 1960s postcard of The Original Dave and Evelyn's is similar to the 1950s interior on p. 103 of *Belmar, Volume I* with a few changes. The sailfish on the knotty pine walls have been replaced with framed pictures, and new ceiling lighting has been installed. The second photograph from the left hanging on the wall is a portrait of co-owner Evelyn Longstreet.

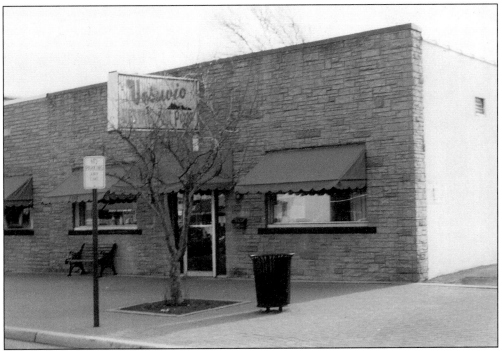

How about a Jim Salad and pizza for dinner? Meet you at Vesuvio's! James Sciarribone and Paul Galluccio opened the Vesuvio Restaurant and Pizzeria in 1937, and two years later the establishment moved across the street to its present location at 705 Tenth Avenue. Jim Salad, named for its creator, the late James Sciarribone, has always been a favorite among diners. The exterior of the restaurant still looks the same as it did years ago. (Vesuvio Restaurant.)

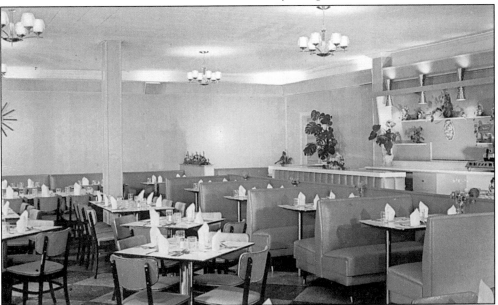

Vesuvio's interior has not changed much over the years. The traditional color of the decor is turquoise. On display are photographs autographed by celebrities who have eaten there, including New York television newscaster Tony Guida.

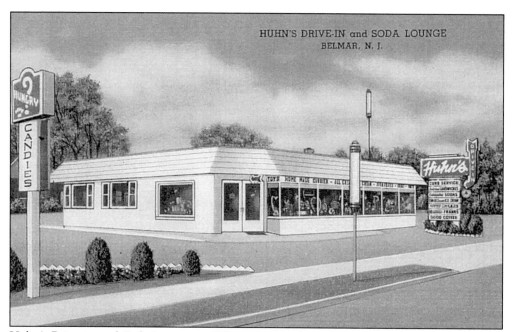

HUHN'S DRIVE-IN and SODA LOUNGE
BELMAR, N. J.

Huhn's Drive-in and Soda Lounge, at F Street and Eighteenth Avenue in South Belmar, is a popular spot to eat, as seen on this 1940s postcard. The place was previously Celia Brown's, the original drive-in and fast-food restaurant of the Jersey Shore (see p. 102 of *Belmar, Volume I*). The site today is the home of radio station WRAT. (Dick Napoliton.)

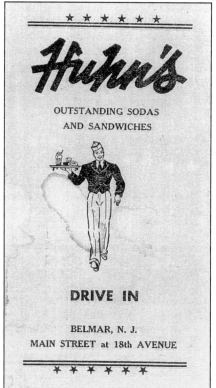

The cover of a 1943 Huhn's menu features a drawing of one of the famous carhops, who got their start when the place was Celia Brown's during the prior decade. Some of the items you could order for 30¢ from the extensive menu included Barbeque Pig and Cheeseburger. For 20¢ you could get Cream Cheese with Jelly. To quench your thirst, you could order a ginger ale or a malted milk for a dime. (Dick Napoliton.)

"Always a friendly welcome with refinement" was the motto of The Yacht Club, Gus Regan's bar and lounge, at the time of this postcard, c. 1940s. The popular establishment at F Street and Ninth Avenue took pride in its cozy, nautical atmosphere.

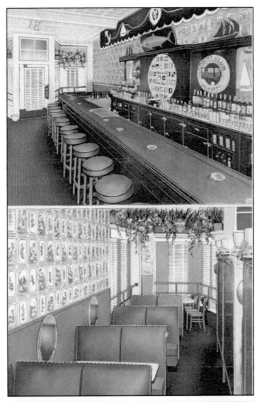

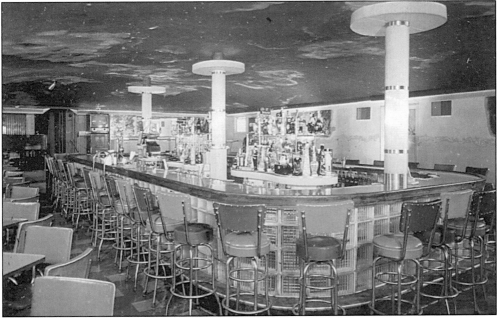

By the 1960s, the era of this postcard view, The Yacht Club lounge had moved to F Street and Seventh Avenue. The larger place was now catering to banquets, and had modern nautical decor. The name changed slightly to become Regan's Yacht Club, but the motto remained the same as it was in the 1940s (see above).

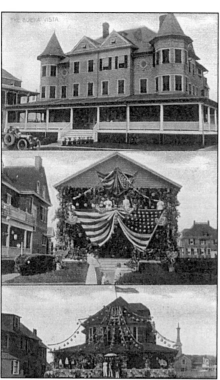

A triple-image postcard from the early 1900s depicts the Buena Vista Hotel on Second Avenue and two decorated cottages, probably near Silver Lake. (John F. Rhody.)

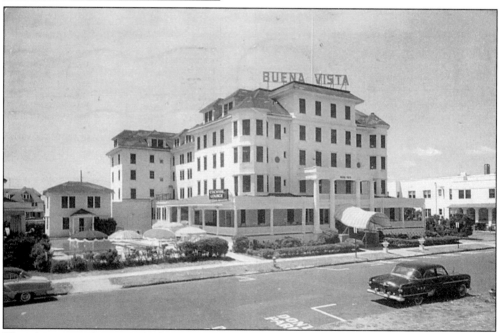

This chrome card, postmarked in 1956, shows the Buena Vista with a swimming pool on the east side. The back of the card says, "Dietary laws observed," as it was a kosher establishment at that time. Located on Second Avenue near Ocean Avenue, the Buena Vista was demolished in the 1960s. (See p. 25 of *Belmar, Volume I* for a c. 1920s view of the hotel; some architectural changes can be observed in comparing the views.)

The Melrose Inn at Ocean and Tenth Avenues looks quite different in this 1920 postcard view than it does today as the Mayfair Hotel. Interestingly, this postcard was sent by an Al Smith to a friend at the Pannaci Hotel in Sea Bright and says to give his regards to "Miss Hilda and Mrs. Pannaci."

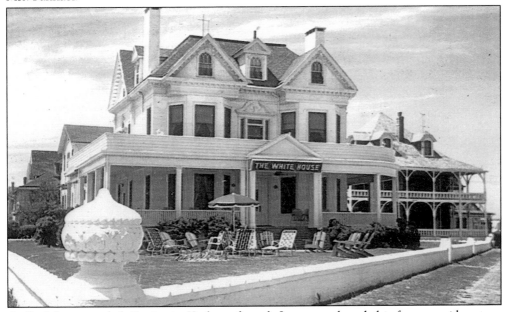

As Prohibition ended, Benjamin Koslow of north Jersey purchased this former residence on Second and Ocean Avenues (see p. 11) and operated it as a kosher hotel from 1930 until 1963. At that time the house, as pictured here on a late 1950s postcard, was acquired by Walter and Edith Wagner, who ran it as a summer guesthouse. The popular seasonal hotel at 102 Second Avenue known as The White House is managed today by the Wagners' son Tom and his wife, Linda. (Tom and Linda Wagner.)

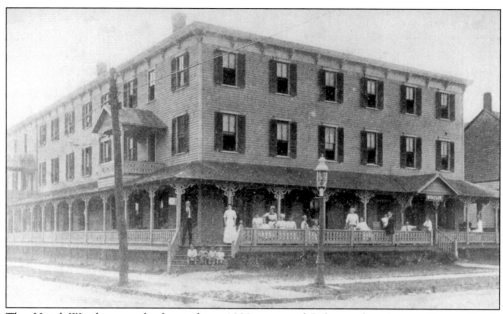

The Hotel Windsor can be located on 1880s maps of Belmar when it was Ocean Beach at the southwest corner of Fourth Avenue and A Street. This postcard view dates from c. 1910. (Moss Archives.)

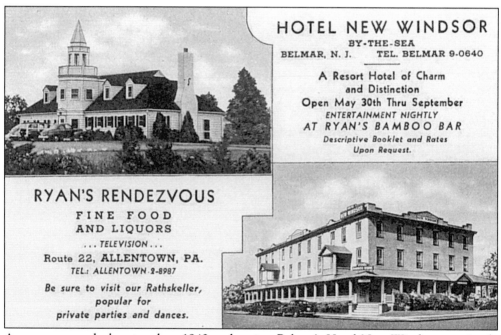

HOTEL NEW WINDSOR
BY-THE-SEA
BELMAR, N. J. TEL. BELMAR 9-0640

A Resort Hotel of Charm
and Distinction
Open May 30th Thru September
ENTERTAINMENT NIGHTLY
AT RYAN'S BAMBOO BAR
Descriptive Booklet and Rates
Upon Request.

RYAN'S RENDEZVOUS
FINE FOOD
AND LIQUORS
...TELEVISION...
Route 22, ALLENTOWN, PA.
TEL.: ALLENTOWN-2-8987
Be sure to visit our Rathskeller,
popular for
private parties and dances.

An uncommon dual postcard, c. 1940s, advertises Belmar's Hotel New Windsor, previously the Hotel Windsor, and Ryan's Rendezvous in Allentown, Pennsylvania. Apparently both places were owned by Ryan, as the Belmar hotel description includes Ryan's Bamboo Bar. (John F. Rhody.)

50

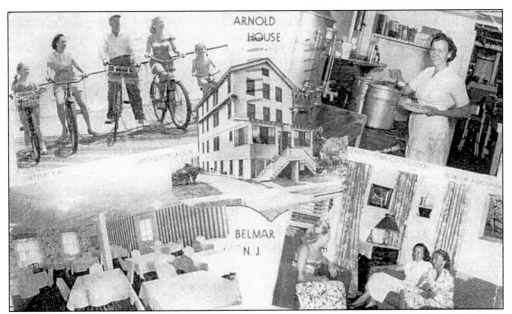

A multi-image postcard of the Arnold House on Fourteenth Avenue, a typical small Belmar hotel of the 1950s, emphasizes family activities, "home-cooked food," and "a homelike atmosphere." (John F. Rhody.)

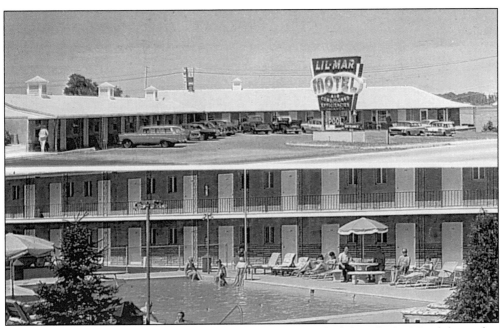

Two horizontal views comprise this c. 1960s chrome postcard of the Lil-Mar Motel, located at Highway 35 and Sixteenth Avenue. It was advertised as "Monmouth County's most beautiful and modern motel overlooking picturesque Shark River." (Jane Gannon.)

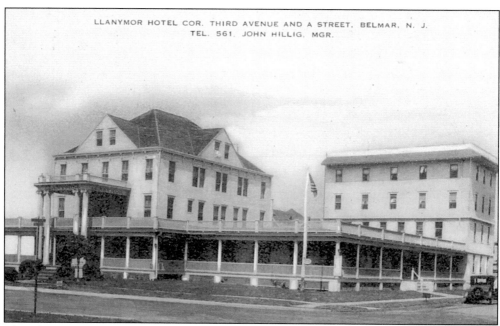

The Llanymor Hotel on the corner of Third Avenue and A Street was a popular vacation destination in the 1920s. In 1954, it was purchased by Thomas Rospos from Elizabeth Hillig, the widow of one-time Belmar councilman John E. Hillig. The hotel burned to the ground in 1968 and was replaced by the Belmar Manor Apartments.

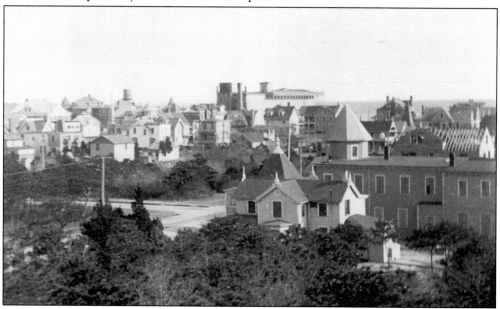

This lofty view c. 1898 was apparently photographed from a tower. The huge Columbia Hotel at Ocean and Third Avenues can be seen in the distance in the approximate center of the photograph. On the right is what is now the Inn at the Shore, recognizable by its tower and rectangular shape, on the southwest corner of Fourth Avenue and B Streets. The house across from it on the southeast corner of Fourth Avenue and B Street is still under construction in this picture, and there is a vacant lot across the street. (Belmar Public Library.)

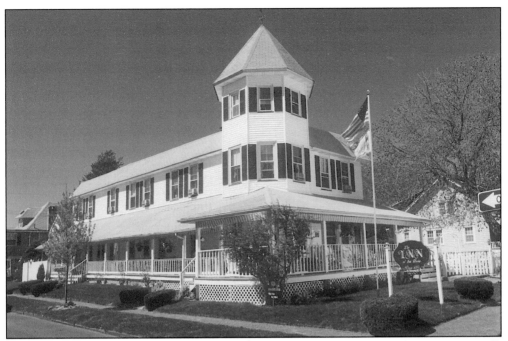

The Inn at the Shore, 301 Fourth Avenue at B Street, recalls the charm of yesteryear's small, cozy hotels. According to the present owners, Tom and Rosemary Volker, the property was originally deeded by the Ocean Beach Association to Timothy W. Lord in 1876. In 1914, it was deeded to Fannie Winterbottom, who then sold it to William Grogan in 1946 when it was called Pine Villa. Ken and Karen Gray became the owners in 1987, and the Volkers purchased the inn in 1994. (Tom Volker.)

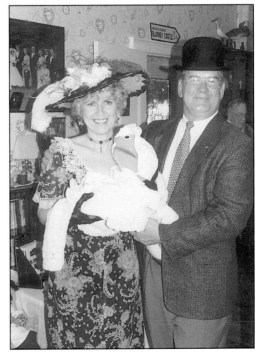

At an April 1999 Victorian tea party, Karen and Leon Schnitzspahn don period costumes and show off their "new arrival" to the guests. Who does the baby look like? (Don't worry, the little darling is only a foam rubber puppet made by Karen!) The event was part of a wonderful reunion of friends held at The Inn at the Shore.

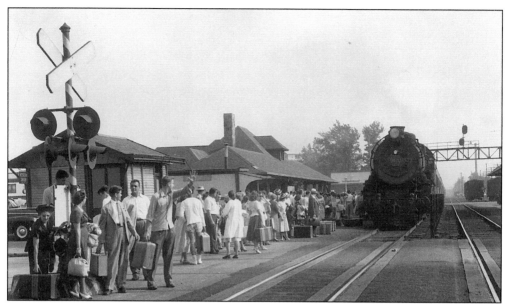

The strains of "Down by the Station, Early in the Morning" can almost be heard while viewing this 1940s photograph of visitors leaving Belmar on a Sunday morning. Just look at that vintage steam engine pulling into the Belmar station, which was built c. 1908. (Steele's Photographic Service.)

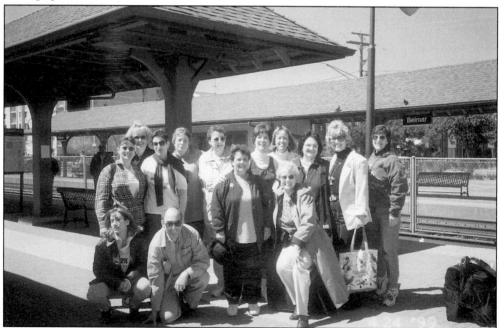

On a Sunday morning in 1999, a group of friends who have just enjoyed a weekend reunion in Belmar wait for the train at the station, which has not changed much in appearance since the photograph at the top of the page was taken. However, a steam engine will not be pulling in, as the trains are modernized now. The people in this photograph hail from not only New Jersey, New York, and Pennsylvania, but also from Rhode Island, Florida, Louisiana, Illinois, and California. (Rose Steffen.)

Four

F STREET AND AROUND TOWN

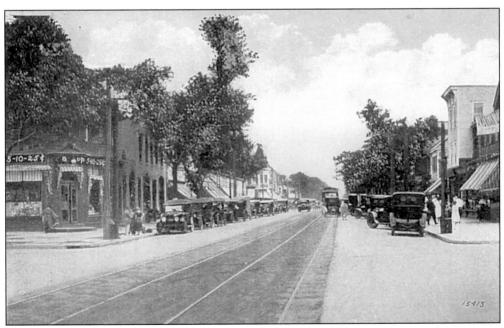

A *c.* 1920s postcard of F Street and Tenth Avenue shows, on the left, a 5-10-25-&-up store on the northwest corner, where Kasdan's drugstore was until 1916, and the old post office next door. Trolley tracks run down the middle of the street, and it appears that it must have been hard to find a parking space. (Jane Gannon.)

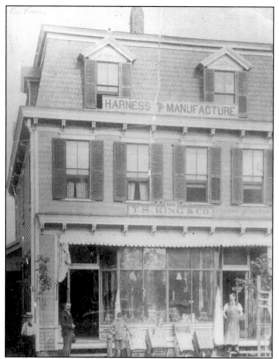

The Freedman's Bakery building on F Street, between Seventh and Eighth Avenues, was once the site of the Harness Manufacture Company owned by Thomas Sydney King, who died in 1929. Above the T.S. King & Co. sign, the date on the building is 1886. Founded in 1950 on this site, the Freedman family establishment has been baking delicious pastry and hot-out-of-the-oven bread for 50 years. Freedman's has expanded and branched out several times over the years. The main store and the offices have always remained in Belmar. (Freedman's Bakery.)

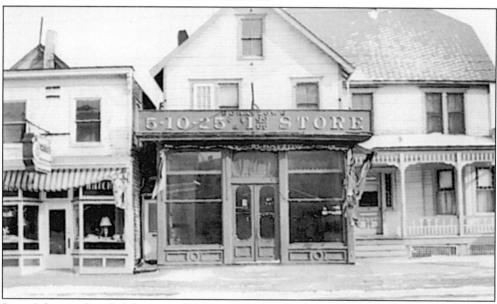

Perry Schatzow founded the original Schatzow's 5&10 Cent Store at 808 F Street in 1939. Long after 5¢ and 10¢ merchandise was gone, the old-time atmosphere lived on at Schatzow's Variety Store. The Schatzow family, who owned the store for three generations, believed their secret to success was customer satisfaction. They prided themselves in carrying little items that could not be found in other variety stores. If they didn't carry it, they made every effort to find it—and usually they did. People joked, "If it's not at Schatzow's, it can't be found." This popular store eventually outgrew its space and moved to a larger location at the corner of Ninth Avenue and F Street (now the site of Eckerd Drugs). (David Schatzow.)

Wight and Pollen, dealers in coal, wood, straw, hay, flour, and feed, had an excellent reputation for low prices and good service for both large and small orders. Also known as Warman's Lumberyard, it was located between Twelfth and Thirteenth Avenues, along Railroad Avenue. The large building in the center of this 1890 picture was used for storage of stock. On the left is Twelfth Avenue, and on the right Thirteenth. The area is currently known as Memorial Field. Notice the passing train in the foreground. (Sterner Lumber Company.)

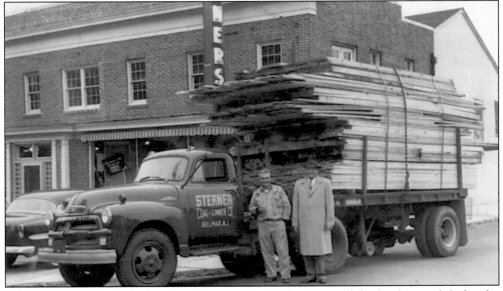

George Sterner, on the right, has a few words with the driver of the lumber truck before he leaves to deliver a load of wood for a house. Loaded on the truck is tongue and groove, or NCT&G, for the building of a new home. When this picture was taken in 1954, plywood was not used in the construction of houses. The Sterner building in the background looks much the same today as it does in this picture and is still thriving with second and third generation Sterners at the helm. (Sterner Lumber Company.)

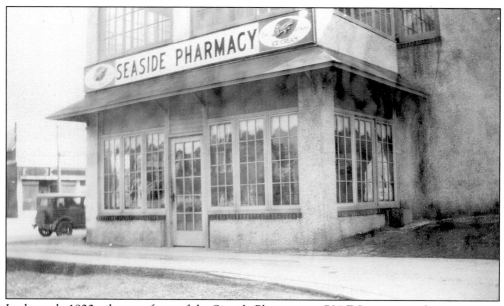

In the early 1920s, the storefront of the Seaside Pharmacy at 701 F Street gives the appearance of a glassed-in porch with French doors, popular in houses of that time.

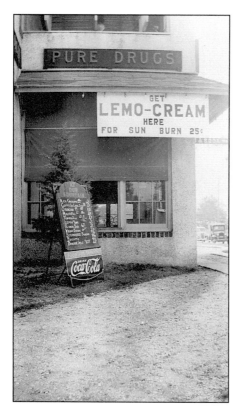

A great side view of the Seaside Pharmacy provides information about products of the 1920s. A sign reads "Get Lemo-cream here for sun burn, 25 cents," and the standing billboard with a Coca-Cola ad gives prices for a variety of fountain drinks. A soda fountain was a feature of most pharmacies in those days. Also interesting is the sign that says "Pure Drugs," perhaps an indication that people were concerned about the quality of the products they used.

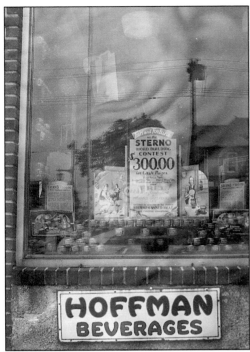

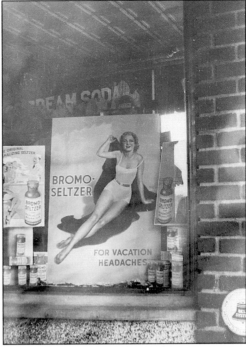

In the photographs on this page, the Seaside Pharmacy storefront has changed. It appears that the old windows have been replaced with larger, modern picture windows. On the left in the window with a Hoffmann Beverages sign below, is the announcement of a word-building contest with a $300 prize, sponsored by Sterno Canned Heat. On the right is a display suggesting that Bromo-Seltzer can alleviate "vacation headaches."

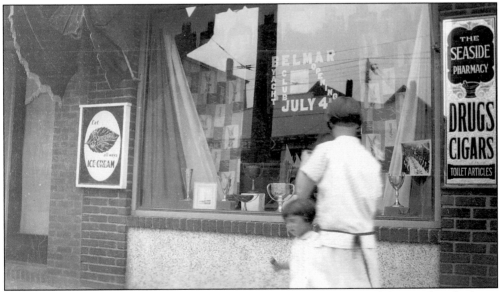

A woman and child are walking by the Seaside Pharmacy. The year of this window display is likely 1928 because it features a special exhibit in honor of the opening of the Belmar Yacht Club on July 4. Trophies and photographs relating to yachting events can be seen in the window. (See p. 79 of *Belmar, Volume I* for yacht club photographs.)

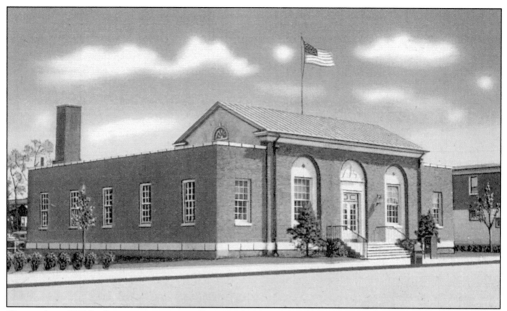

Opened in 1936, the current post office at the corner of F Street and Thirteenth Avenue is shown here in a 1940s linen postcard. Young Robert Sherman won first prize for his essay on the history of the Belmar Post Office in a 1936 contest open to local schoolchildren and sponsored by the Kiwanis Club. This was the first permanent, government-owned building used as a post office for the borough and helped to increase development of the town around the south end of F Street, later to be called Main Street.

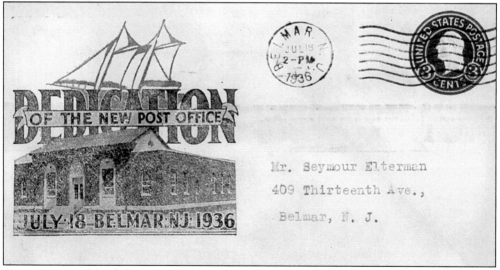

As a memento of the dedication of the new post office, the Belmar Chamber of Commerce issued this commemorative first-day cover, now a collector's item. The envelope's design featured a photograph of the building and an artistic background drawn by Henry Bernie.

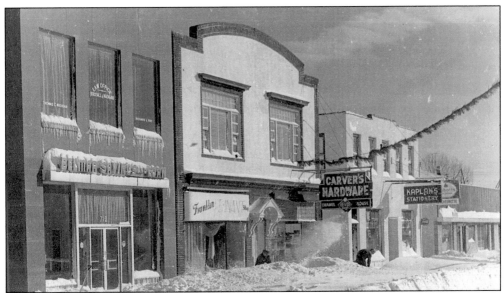

Children love it and adults are inconvenienced by it. What could it be? Of course, it is a snowstorm. On the left Belmar Savings and Loan, once the site of the post office and now the Sovereign Bank, is open for business. Franklin's Remnant Shop, located next door and owned by Jacob Franklin for 25 years, "carried everything," according to his daughter, Millie Goldberg. Local residents were not Franklin's only customers. He had customers come from all over the world. He made them feel at home because he spoke to them in their native language—he spoke 14! Coauthor Sandra G. Epstein remembers all of the containers of buttons throughout the store, which were sold by the scoop. It was a treat to sort through and match all the different buttons, keeping the children busy while their mothers shopped. (Taylor Hardware.)

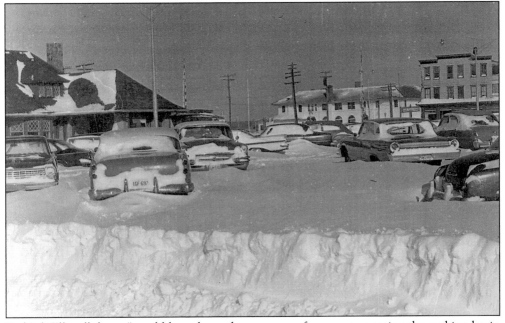

"I think I'll walk home" could have been the response of commuters seeing the parking lot in this undated railroad station photograph. (Taylor Hardware.)

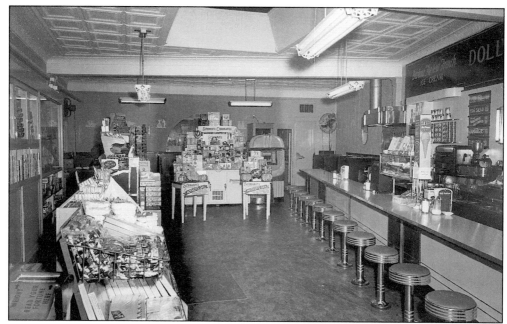

This 1948 image provides a great look at the interior of a stationery and confectionery store that was located at 1603 F Street and operated by Max Scorben. The photograph was taken for publicity use after the store was refurbished. Chocolate lovers, don't miss the yummy display of Schrafft's chocolates at the back of the store. (Steele's Photographic Service.)

This stationery store, operated by Frank H. and Jean Lyons in the 1940s, moved from 711 to 804 F Street. In the rear is a lending library, and on the right is a book section. If the store were in existence today, perhaps some Images of America books would be on those shelves, including *Belmar, Volumes I and II*. (Steele's Photographic Service.)

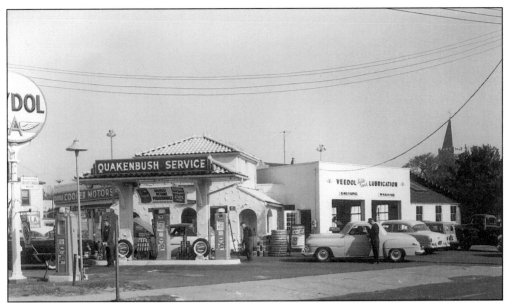

"Fill 'er up and check the oil" was probably a familiar phrase in 1929 when William Quakenbush Sr. opened the Quakenbush Service Station on the corner of Eighth Avenue and F Street. William's son Bill joined the family business and operated it until his retirement in 1986. A used-car lot belonging to Sea Coast Chevrolet/Oldsmobile now occupies the corner. In this photograph taken in November 1954, the station is busy with several customers. (See the lower left corner of p. 101 of *Belmar, Volume I* for an aerial view of the station and Belmar Motors.) (Steele's Photographic Service.)

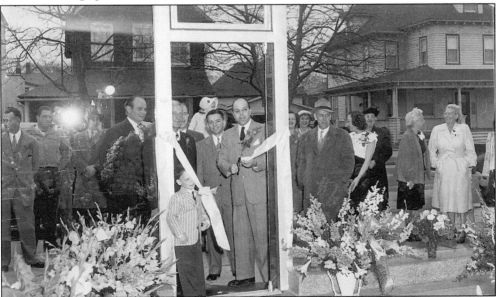

On April 8, 1948, Belmar Mayor Peter Maclearie cuts the ribbon to open the new headquarters of Central Motors, agents for De Soto and Plymouth automobiles made by the Chrysler Corporation, at 601 F Street. Looking on, from left to right, are the owners, the William Gundakers Jr. and the William Gundakers Sr., with William S. Gundaker III in the foreground, and commissioners Howard Hayes and John Ferruggiaro. (Steele's Photographic Service.)

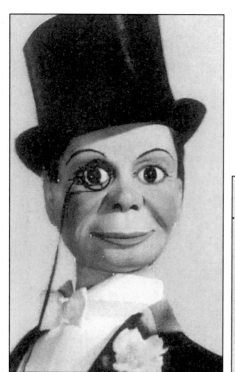

An F Street landmark that evokes fond memories, the Rivoli movie theater near Ninth Avenue is now closed but the old marquee is still there. Here's a ticket to win a replica of Charley McCarthy, Edgar Bergen's dummy sidekick, which was to be given away on the stage of the Rivoli, c. late 1930s. The ventriloquist's act first became famous on radio; so initially, Bergen did not have to worry about anyone seeing his lips moving. (Ticket courtesy of Dick Napoliton.)

N⁰ 2788 **FREE!**
Keep This Stub

You May Win a Likeness of
CHARLEY McCARTHY
Radio's Number One Personality
Will Be Given Away on the Stage of the
RIVOLI THEATRE
3 Given Away Each Sat. and Sun. Mat.
Feb. 19 - 20, Feb. 26 - 27, March 5 - 6

YOU MUST BE PRESENT TO WIN

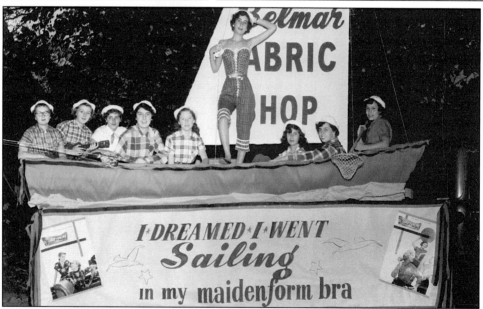

It is smooth sailing for a crew of teenagers at the annual Halloween parade on F Street, c. 1949. The sailors, from left to right, are Aubria Schlesinger, Jean Litowinsky, Roslyn Hirsch, Rose Thompson, Barbara Myers, Lois Schneider in a costume considered risqué at the time, Irene Marx, Barbara Harad, and Marilyn Weinstein. Flora Schneider, Lois's mother and the owner of the Belmar Fabric and Specialty Shop, "was full of fun and always dreaming up parties and events," according to crew member Marilyn Weinstein Fliegler. She made her sailing dream come true with this float. (Beverly Weinstein Kaplan.)

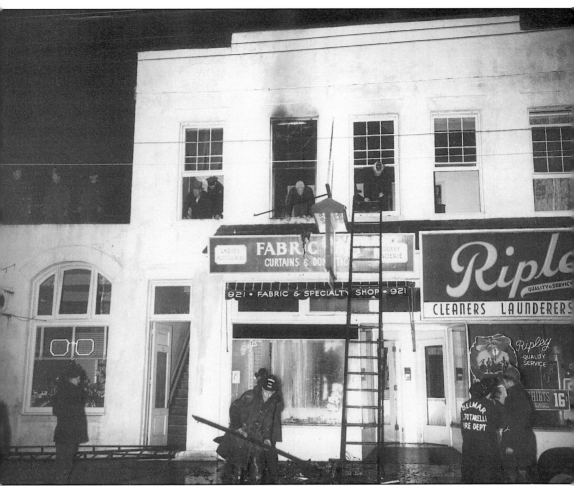

In the mid-1940s, Herman and Flora Schneider opened the Belmar Fabric and Specialty Shop at 921 F Street and remained in business until the mid-1950s. According to their daughter, Lois Schneider Goldberg, they carried a complete line of fabrics, patterns, and notions, plus a line of ladies accessories including lingerie, blouses, and sweaters. "The store was noted for its outstanding window displays. It also sponsored a float in all the Halloween parades. One of the big events during the early 1950s was a major fire in one of the apartments located above the fabric shop. Herman believed the man who lived in the apartment was still upstairs and he ran up to rescue him. Flora was in New York on a buying trip that day." When Flora's sister Minnie heard the location of the fire, she came running down the street yelling, "Get the money and get the hell out of there!" The family was upset when they could not find Herman and were told that he had gone upstairs to rescue anyone in the apartments. However, Herman was safe. Upon her return home, Flora saw the empty front window and said, "I guess we have to call the window trimmer and get another beautiful window decorated." After selling the fabric shop, Flora helped her sister and niece at Yore Drug Store. Herman went to work as a liquor salesman for Weinstein's Liquor Store. Flora died in 1991 and Herman in 1994. (Steele's Photographic Service.)

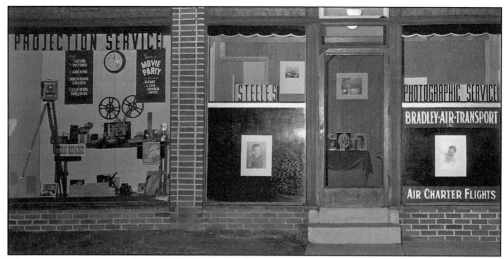

This c. 1948 image of the storefront of Steele's Photographic Service at 700 Ninth Avenue was taken by owner/photographer Gil Steele, to whom this book is dedicated. Originally from Elizabeth, New Jersey, Gil served in the Navy during World War II and acquired his photographic skills while in the service. (All photographs of the store are by Steele's Photographic Service.)

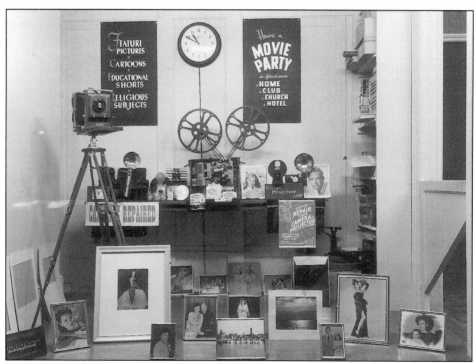

Professional photographer Gil Steele possessed the foresight to document his store window c. 1948 for posterity. Seen in a closer view of the display window are cameras of the day now considered collectible, samples of family portraits, pictures of glamour girls, and one of Gil's local images of boats at the Belmar Marina, at the bottom center. A classic 8 mm projector is the centerpiece. A sign suggests having a movie party in your home, club, church, or hotel—a precursor of today's video rentals.

Are you old enough to recognize this fellow? If so, then you will remember his announcement, "Call for Philip Morris!" Johnny was well known in the 1940s and 1950s as the bellhop in the cigarette commercials that are now only a part of social history. Here, he poses in front of Gil Steele's studio at 700 Ninth Avenue while visiting Belmar. In the photograph on the right that is autographed "With my best wishes to my friend Gilbert," Johnny has put his sunglasses on to take in some of the Belmar sun. (Steele's Photographic Studio.)

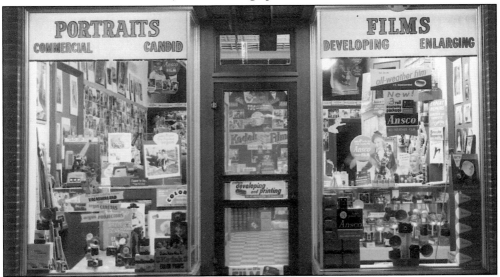

Here is the storefront of Gil Steele's second store at 703 Ninth Avenue, just across the street from the store shown on the opposite page. Once again, the busy photographer documented his business venture for future generations. (Steele's Photographic Studio.)

Silverstein's Market puts on a new face. Standing, from left to right, are Milton Cohen, Pete Peterson, Dave Silverstein, Jerry Lagotte, and proprietor Ben Silverstein at the grand reopening of their enlarged market. Silverstein's was a small family-owned grocery that opened in the early 1920s at 904 F Street and was enlarged in the late 1940s. Customers, many of whom were also friends of the family, were always welcomed with a warm greeting. Years later when the family closed the grocery, Gil Steele enlarged his camera store, added a travel agency, and moved his studio into the vacant store.

These windows were those of Gil Steele's last store at 904 F Street. He operated his thriving photographic business and travel agency in Belmar until the early 1960s. The location was the former site of Silverstein's Market (see above).

Five

YESTERDAY'S CHILDREN

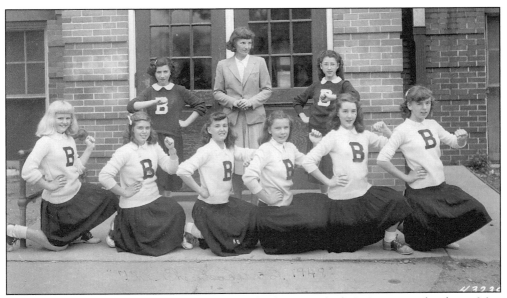

Go Belmar! The Belmar Public School's cheerleading squad of 1948 poses with adviser Miss Markus. The members, from left to right, are as follows: (front row) Barby Terhune (now Barbara Preising, who provided this photograph), Jean Maclearie, Maria Galluccio (Hernandez), Dolores Patterson, Margie Mosely, and Elinor Lowell; (back row) June Frishman (second captain) and Vivian Sylvester (captain).

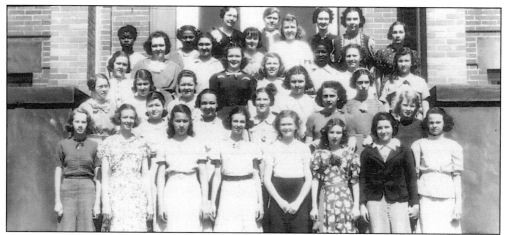

Graduation 1937 and the girls pose on the front steps of Belmar Grammar School. They are, from left to right, as follows: (front row) Ruth Heulitt, Janet Haberstick, Marjorie Conover, Marjorie Haberstick, Jane Bearmore, Lillian Lorber, Reba Rosenbaum, and Clair Gordon; (second row) Ruth Fishman, Delores Decanay, Alice Veron, Virginia Kuehner, and Marion Burkett; (third row) Mildred Potterfield, Leona Traub, Alice Tate, Jean Hensler, Lucille Huber, Evelyn Anderson, and Janet Patterson; (fourth row) Adeline Trasborg, Doris Gundaker, Shirley Kravitz, Marie Thornley, Adeline Kleinkauf, Levina Smith, Lenore Rosen, and Elva Burge; (back row) Alfreda Smith, June Jackson, eighth-grade teacher Bessie Pearce, Principal Ella Ricketts, eighth grade teacher Miss Withrow, Ruth Brown, and Harriet Brice. (Bill Wilkins.)

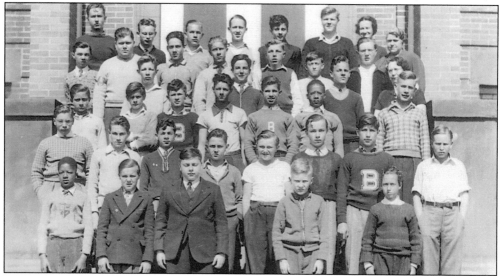

Pictured are, from left to right, the boys of the 1937 class: (front row) Jim Davis, Tom Barton, Dick Lewis, Herb Blaicher, and Ernie Clark; (second row) Larry Rachlin, Jim Brice, Herb Sekular, Bob Pflug, Bell Eggimann, Bob Watkins, Jerry Bernstein, and Glenn Bayard; (third row) Nick Paternoster, Bob Redden, Jack Haberstick, Ralph Coggiano, Gabe Ferretti, James Nicholson, and Hal Manson; (fourth row) Lloyd Tranter, Norm DeRoche, Jim Burton, and teacher Bessie Pearce; (fifth row) Bud Ward, Bill Wilkins, Joe Horton, Howard Dunfee, Tylee Newman, Don Newmann, Bert Bills, and Principal Ella Ricketts; (back row) Jay Sterner, Bob Scisco, Bill Brown, Jim Garrabrandt, Sid Rosen, Bill Hensler, and teacher Miss Withrow. (Bill Wilkens.)

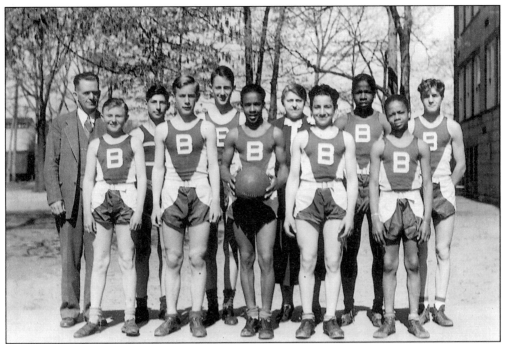

Belmar Grammar School's 1937 boys' basketball team poses for its annual photograph. Pictured are, from left to right, the following: (front row) Bill Eggimann, Hal Manson, James Nicholson, Ben Ciallella, and Joe Miller; (back row) Coach Lon Crandall, Jerry Bernstein, Jim Garrabrandt, Principal Ella Ricketts, Snooks Smith, and Art Kugler. (Bill Wilkins.)

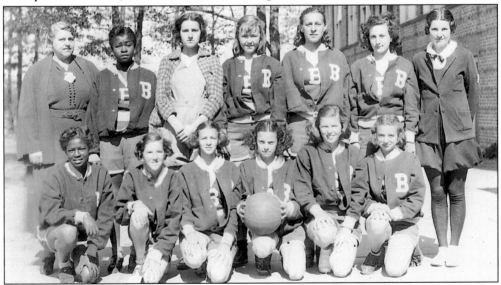

Not to be outdone by the boys, the girls also had a basketball team. In this 1937 photograph are the following, from left to right: (kneeling) LaVina Smith, Alice Veron, Janet Haberstick, Clair Gordon, Lucille Huber, and possibly Virginia Kuehner; (standing) Principal Ella Ricketts, Alfreda Smith, Doris Pflug, Adeline Kleinkoff, ? Sagui, and possibly Virginia Keuner. The coach on the far right was identified as Miss Barker but appears to be Natalie Marcus (McAllister). (Bill Wilkins.)

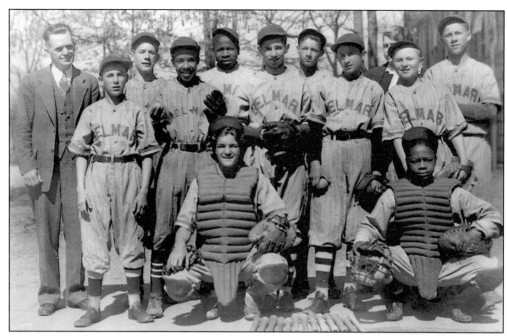

Could the smiles on most of the faces of the 1937 baseball team mean they had a winning year? Shown here are, from left to right, the following: (front row) Art Kugler and Joe Miller, two catchers; (middle row) Sonny Cowdrick, James Nicholson, Gabe Ferretti, Jack Haberstick, and Bill Eggimann; (back row) Coach Lon Crandall, Hal Manson, "Snooks" Smith, Ralph Coggiano, Principal Mrs. Ricketts (partially obscured), and Howard Dunfee. (Bill Wilkins.)

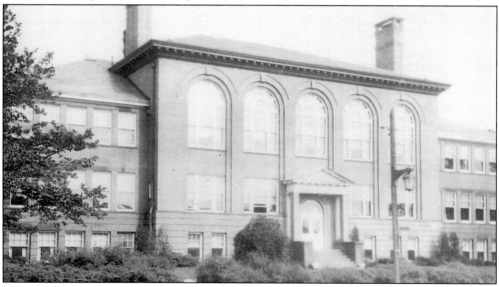

The steeple that once stood on the roof of the Belmar Grammar School was taken down after a 1947 fire on the third floor and never replaced, as you can see in this c. 1949 picture. (For a comparison, see the 1910 picture on p. 109 of *Belmar, Volume 1*). Although the inside of the building has been remodeled several times during the past 80 years, the exterior, other than additions, has changed very little. Each year the graduating class poses on the steps for its official picture—a tradition for several generations. (Belmar Board of Education.)

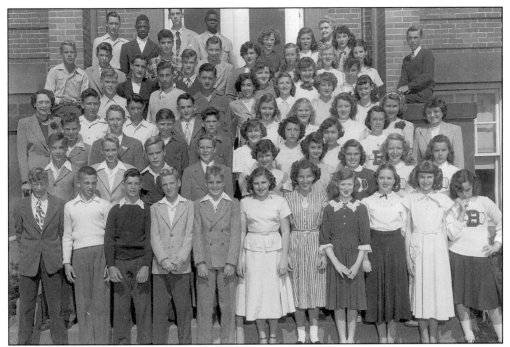

The Belmar Grammar School Class of 1949 poses on the steps of the school. In the fourth row on the left is eighth grade teacher Dorothy Pearce; across from her on the right is eighth grade teacher Goldie M. Fincke, who later became principal; and on the top right is Principal Ella Ricketts. (Barbara Terhune Preising, who loaned this photograph, had moved to the West Coast just before this photograph of her class was taken.)

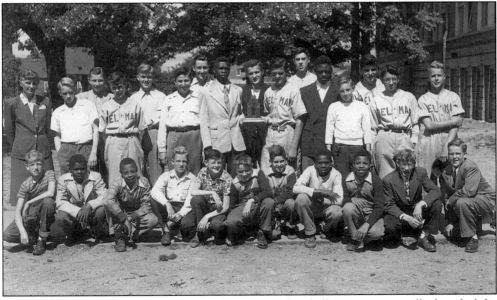

The players on Belmar Grammar School's 1948–49 baseball team are not all identified for this photograph, but readers who remember that era will surely recognize many familiar faces. Adviser Natalie Marcus is on the left, and Kenny Pringle is holding a trophy in the center. (Barbara Terhune Preising.)

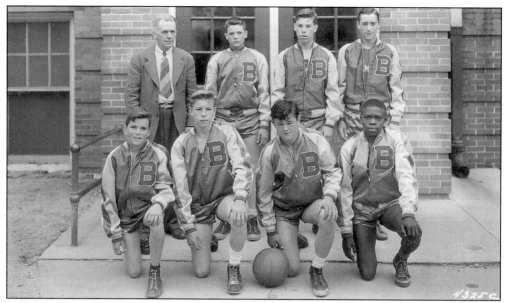

Posing in their green-and-white satin jackets for a 1948 portrait are the Belmar Grammar School basketball team members. Pictured are the following, from left to right: (front row) Gene Cavanaugh, Richard Stoner, Joe Carmella, and Benny Lattimer; (back row) Coach Lon Crandall, Bobby Noe, Charles Humphrey, and Harry Newman. (Barbara Terhune Preising.)

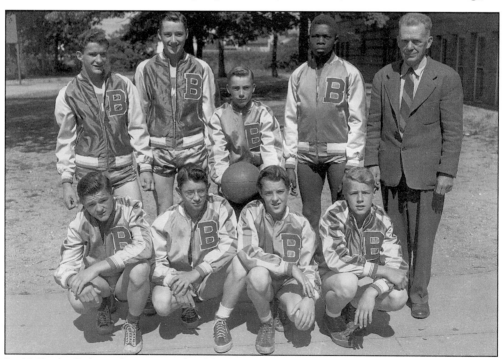

In 1949, the Belmar Grammar School basketball team assembled for an annual photograph. Pictured here, from left to right, are as follows: (front row) Joe Carmela, Jay Vola, Ross Stoner, and Jack Duvall; (back row) Kenny Pringle, Harry Newman, Sonny Cowdrick, Benny Lattimer, and Coach Lon Crandall. (Barbara Terhune Preising.)

74

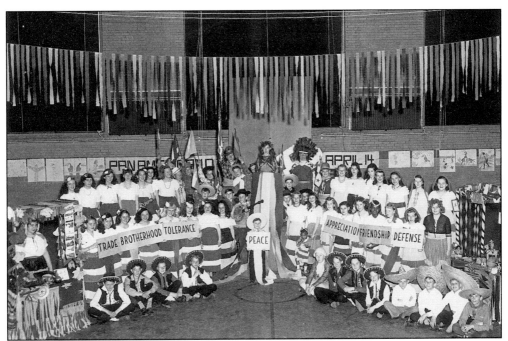

On April 14, 1948, Belmar Grammar School seventh-graders put on an impressive Pan American Festival in celebration of our neighbors south of the border. The event was directed by teacher Marion S. Cleaver. More than 60 students appear in this photograph taken inside the school's gymnasium. (Steele's Photographic Service.)

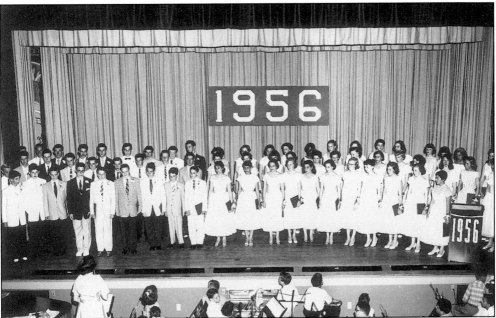

"To do your best is the way to success" is the motto of the class of 1956. The graduating class stands together for one last time after receiving diplomas at their June 13 graduation ceremony. In the orchestra pit, music teacher Bertrice Galloway is preparing to lead the class in the singing of their farewell song. (Steele's Photographic Service.)

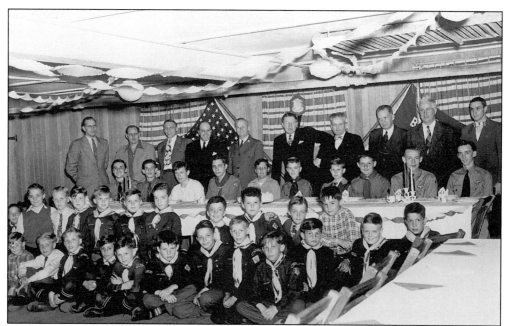

The annual Boy Scout treat, sponsored by the Scout Mother's Auxiliary of Troop 40, Belmar, was held on April 21, 1948, at the First Presbyterian Church. Standing in back were guest speakers, from left to right, Kenneth Stanley, Chester Davison, George Gregory, Mayor Peter Maclearie, John Northup, emcee Edward Broege of the Monmouth Council of Scouts executive board, Everett Antonides, Lon Crandall, Cyril Clark, and Scoutmaster Fred Leiner. (Steele's Photographic Service.)

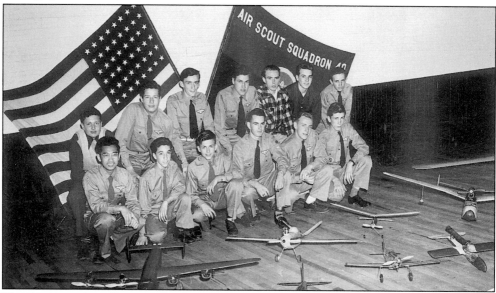

The Air Scout Squadron 40 of Belmar held its annual model aircraft show on May 14, 1948. Showing off their planes, from left to right, are the following: (front row) Young Eng, James Coles, Bob Schedlinger, Ronald Thompson, Ken Laursen, and Wes Jost; (back row) Bill Wilderspin, David Barton, Chester Davidson, Jack Foster, Wayne Gibson, Dick Lang, and Bob Kisner. (Steele's Photographic Service.)

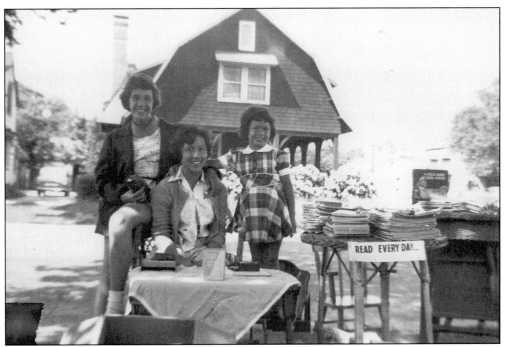

Two entrepreneurs and one assistant started their own variety store on the corner of Eleventh Avenue and B Street in 1953. Encouraging people to read everyday, Sandra Granoff, Beverly Weinstein, and assistant Ronnie Granoff raided their houses for magazines, comic books, and various trinkets to stock their business. Sandra and Beverly worked every day for two years and happily divided $20 when they went out of business in 1955. Ronnie volunteered her time.

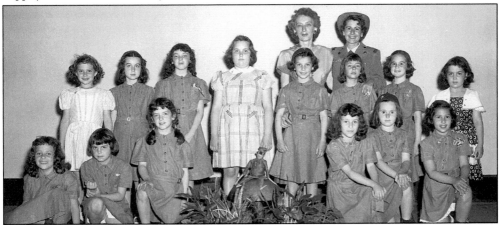

The Brownie Investiture is an important event for these future Girl Scouts. Following a c. 1949 ceremony that took place around the "lake" surrounded by plants (in the center), the Belmar troop poses for its first photograph as official Brownie Scouts. From left to right are as follows: (front row) Carol Biesky, Mary Troger, Suzanne Kaufer, Susan Biesky, unidentified, and Beverly Weinstein; (middle row) Michelle Laifer, Adele Silverstein, Myrna Rosen, Cynthia Morris, Joanne Zuckerman, Sandra Granoff (who went on to eventually become a Girl Scout leader), Irene Torop, and Alice Fishman; (back row) troop leader Gus Kaufer and an unidentified woman. Looking closely, you can see the Brownie sitting in the middle of the "lake." (Steele's Photographic Service.)

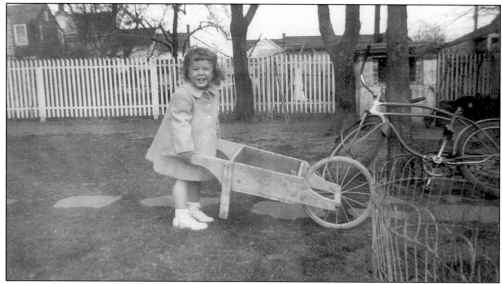

"Mary, Mary, Quite Contrary, How Does Your Garden Grow?" In the late 1940s, Mary "Boodie" Christian pushes a wheelbarrow in the backyard of the Pierce home at 519 Sixth Avenue. Boodie and her parents lived in the garage apartment at the Pierce home. (Mary Christian.)

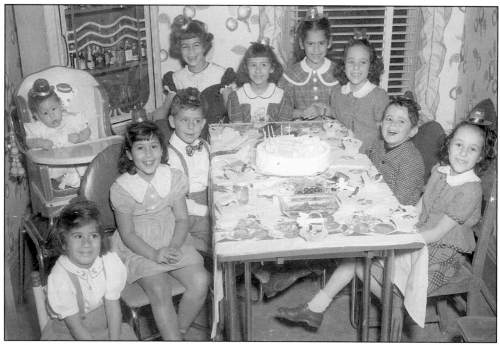

In this December 1948 picture, Sandra Granoff celebrates her sixth birthday with some of her closest friends and relatives at her home on Eleventh Avenue and B Street. From left to right are Sherry Kaplan, Beverly Weinstein, Dennis Hollander, unidentified, Sandra Granoff, Bonnie Horowitz, twin Carol Biesky, Bruce Biesky (Carol and Susan's brother, who now has twins of his own), and twin Susan Biesky. The guest in the high chair is Sandra's six-month-old sister, Ronnie, who looks bored by it all.

On the east side of the house at 416 Tenth Avenue, Mary Newberry holds on to her son Richard to be sure he does not fall, c. 1928, but he seems very confident on the pony. Each summer, a traveling photographer came with a real pony, such as this one, or a stuffed dog to pose the children with while he took their portraits. (This photograph of his grandmother and father is courtesy of James J. Newberry.)

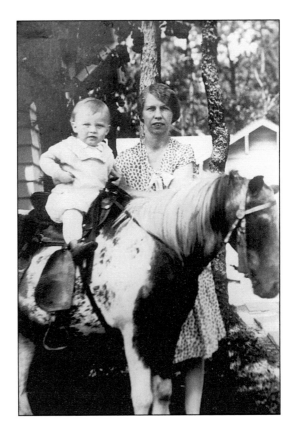

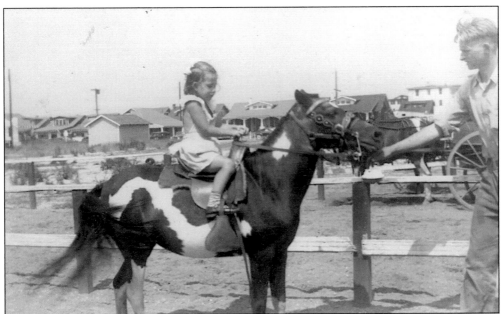

Five-year-old Eileen Collins looks a little apprehensive as she holds on to the saddle with both hands and prepares for a pony ride at the Belmar Playland on Fifteenth and Ocean Avenues. This c. 1942 view was taken looking north. (Bruce Allen.)

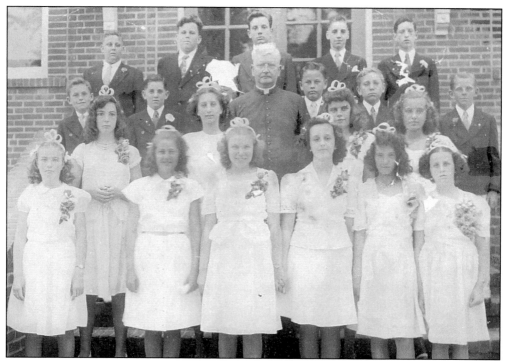

The St. Rose Grammar School Class of 1946 poses on the front steps of the school, dressed in their graduation finery. Standing, from left to right, are the following: (first row) Betty Fay, Connie Shields, unidentified, unidentified, Jackie Cooper, and unidentified; (second row) unidentified, Mary Haberstick, Pat McCarthy, and Eileen Byko; (third row) Buzzy McDermott, Steve Keane, Father O'Sullivan, Bob Malone, Alex Landi, and Walt Mueller; (fourth row) Joe Fejes, Tom Kelly, Cliff Hamel, Bill Antonides, and John Gilhooly, who provided this photograph.

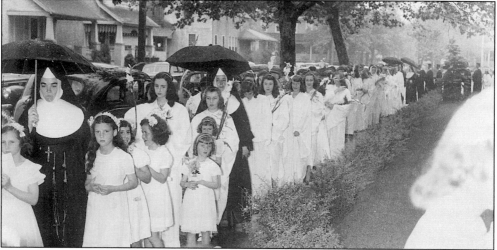

Confirmation Day, and it is raining. Sr. Rita Eileen leads the confirmation class along E Street and Seventh Avenue and into the St. Rose Church, around the corner. In this memorable image, which has an almost ethereal look to it, the sisters are holding umbrellas, but nobody seems to mind the rain. (Steele's Photographic Service.)

Six

PORTRAITS OF SOME BELMAR PEOPLE

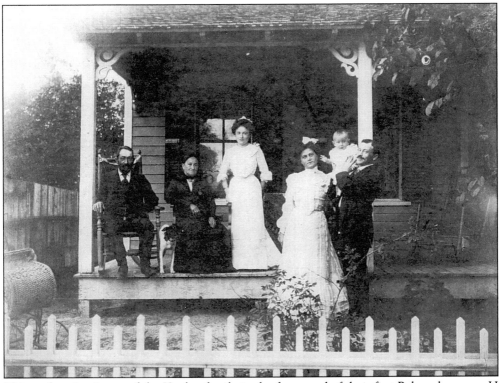

This enchanting image of the Kasdan family in the front yard of their first Belmar house on H Street near Sixteenth Avenue is a fine example of portraiture depicting family life at the Jersey Shore a century ago. Jacob Kasdan sits in the rocker, with the family dog beside him. To his right on the porch is his wife, Fannie, and their daughter Rose. Their son Robert, a pharmacist, and his wife, Mary, proudly show off their first child, Alfred, whose wicker carriage is visible on the left. (See *Belmar, Volume I*, chapter six, as well as chapter seven of this volume, for more images of the Kasdan family.) (Claire Kasdan Angrist.)

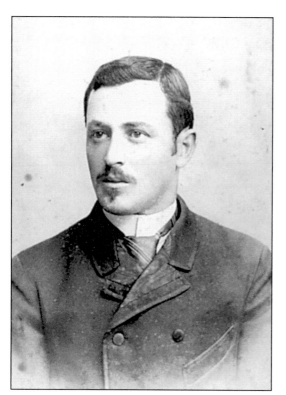

Before he left Riga, Latvia, to make his new home in America, Belmar pharmacist Robert Kasdan posed for this *carte-de-visite* photograph, which became a cherished possession of his daughter Claire. (Claire Kasdan Angrist.)

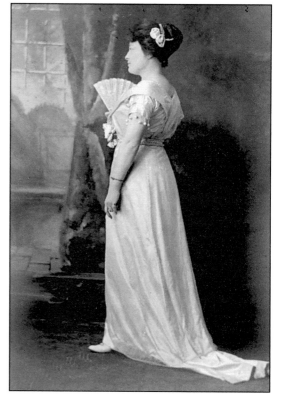

An exquisite "back" portrait of Rose Kasdan, Robert's sister, provides a splendid example of a pose that was popular in the late 19th century. The beauty of this Rose from Belmar could surely be said to be another reason for the "Bel" in Belmar, a version of the French *belle mer*, meaning "beautiful sea." (Claire Kasdan Angrist.)

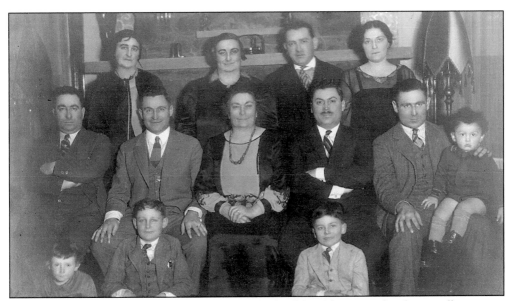

Gertrude Silverstein, a young widow and matriarch of the Silverstein family, proudly poses at the center of her family for a formal portrait in 1925. Members of her family, from left to right, are as follows: (front row) grandchildren Selma, David, and Norman; (middle row) children Lou, Joe, Max, and Ben, and grandson Sam; (back row) daughter-in-law Tillie, daughter Anna Goldstein, Max Goldstein (Anna's husband), and daughter-in-law Ceil. Lou was the owner of Lou's Bar and Grill (see p.e 43). Joe, a lawyer, was at one time borough attorney. Ben, Dave, Anna, and Jack operated Silverstein's market (see p. 68), which was started by Gertrude and her husband. (Gail Silverstein Bram.)

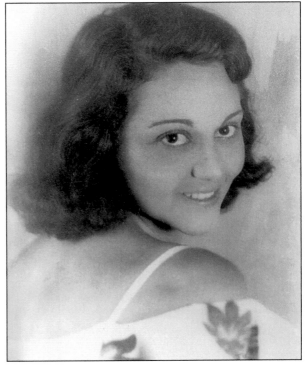

The beautiful Olga Kaplan, shown here c. 1930, "loved Belmar," according to her daughter, Judy Hurley. After moving to Belmar when she was 18, Olga met her husband, Sam. Olga and Sam raised four children and ran the family business, Kaplan's Stationery Store on Tenth Avenue. When Olga was in her forties, she decided to branch out on her own and opened Olga Kaplan Real Estate, a thriving venture until her death in 1992 at age 80. (Beverly Weinstein Kaplan.)

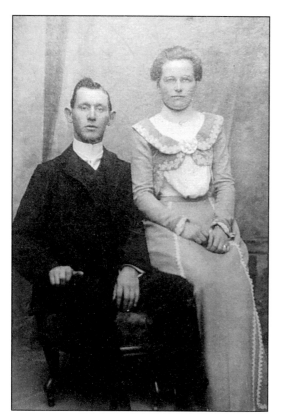

George (1878–1915) and Emma (1878–1965) Newbery (spelled with one "r") sit for a sedate-looking portrait, typical of those taken c. 1900. From about 1910 to 1918, the couple operated a dairy across from the Belmar railroad station, where the building known as 707 Tenth Avenue is located. (James J. Newberry.)

Lee Abbott (standing) and a friend, Frend John Newberry, posed for a photograph c. 1918–20. Abbott served as a mayor of Belmar from 1939 to 1947. The photograph is courtesy of James J. Newberry, grandson of Frend.

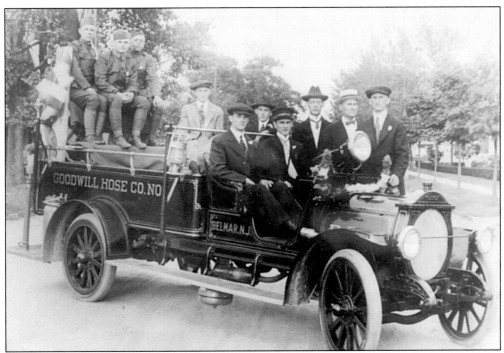

Sitting in the back of Belmar's Goodwill Hose Company's truck in 1918 are victorious soldiers who were in the Great War, later to be known as World War I. The soldier on the left is Daniel Jones Jr., and the civilian in the middle of the truck is Arthur Davenport. Arthur's brother, Louis Davenport, is on the far right. Notice the resemblance? James J. Newberry provided this photograph and identified the three men, who are his uncles.

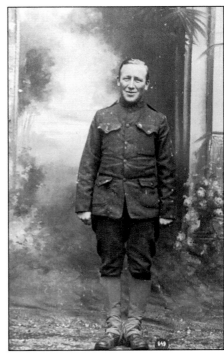

This studio portrait of a soldier in his World War I uniform is autographed on the back "To Mother, from Dick." Belmar's William Richard Kieckle was born in 1899 and lived until 1966. (Belmar Public Library.)

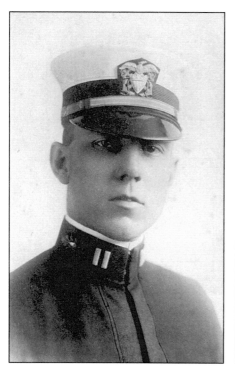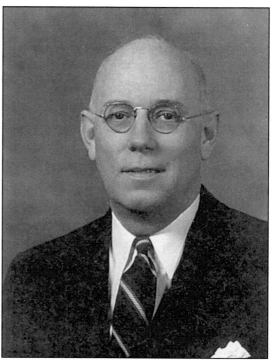

Dr. Robert E. Watkins, a Belmar physician and humanitarian, died after an eight-year bout with illness at the age of 51. His obituary appeared on the front page of the *Asbury Park Press* on December 23, 1942. The following excerpts from the obituary show the vast scope of his career: "Dr. Robert E. Watkins, well-known Belmar physician and church and welfare worker, died yesterday in Fitkin Hospital. A graduate of Davidson College, Class of 1912, and Jefferson Medical College, where he received the M.D. degree in 1917, Dr. Watkins was a veteran of the last war. He enlisted in the navy when the United States entered the war and after his graduation from Jefferson Medical College. As a lieutenant, he served for more than two years in transport service, carrying troops to Europe and removing wounded soldiers to this country. He was with the staff of the former Ann May Hospital, Spring Lake, and on pediatric service at Fitkin Hospital (now Jersey Shore Medical Center). He was also in charge of baby clinics at Neptune and Freehold. He was also school physician for Wall Township and Spring Lake Heights before illness forced him to retire. Dr. Watkins was a former treasurer and past president of the Monmouth County Medical Society. His activity in church and welfare work included membership on the Monmouth County YMCA board, the board of governors of Allenwood Hospital, and the session and board of trustees of Belmar First Presbyterian Church. He was also chairman of the troop committee of Boy Scout Troop 40, vice chairman of the Belmar branch of the Red Cross, past chairman of the Belmar Auxiliary of the Monmouth County Organization for Social Service, cochairman of the Belmar Go-to-Church committee, and a member of the Belmar Board of Education. In addition, Dr. Watkins was a past president of the Belmar Kiwanis Club, past president of the Belmar Community Center, and a member of the Ocean Lodge of Masons and the Herbert-Worthington-White post of American Legion." These portraits of Dr. Watkins in his navy days (left) and in his later years (right) are courtesy of his son, Robert E. Watkins Jr.

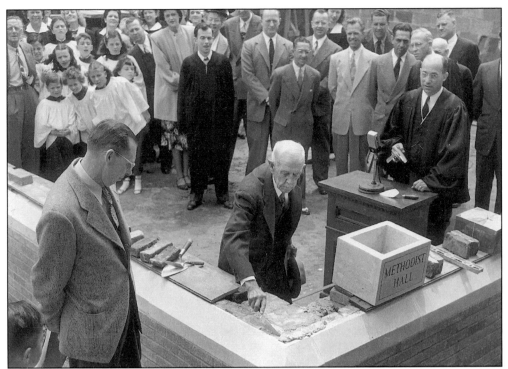

In 1948, the Rev. Lawrence G. Atkinson, pastor of the Belmar Methodist Church, conducted an outdoor service at the site of the new Fellowship Memorial Hall, Seventh Avenue and D Street. William Heyniger, a member of the church for 70 years, places the first trowel of cement as the crowd looks on. (Steele's Photographic Service.)

Posing with, and partially hiding, the new fire truck in this 1949 picture are, from left to right, William Vernon, August Galluccio, Charles Vernon, Paul Wagner, Harry Pearce, Les Thompson, Harry Pflug, Jack Goldstein, Henry Wooley, Sam Wooley, unidentified, Artie Totarelli, Paul Brand, Lou Cierpial, Elwood Walzer, Bob Brand, Harold Thompson, Wolcott Pearce, Clarence Keim, Howard Haberstick, and Edward Kleinkauf. The children sitting on the truck are unidentified. (Bob Brand.)

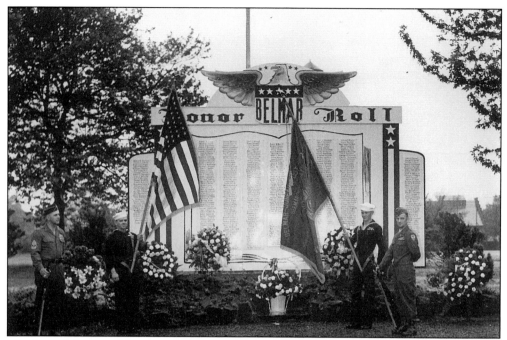

Members of the armed forces proudly stand at attention in front of Belmar's Honor Roll, in this undated photograph. The World War II memorial, which once stood between Twelfth and Thirteenth Avenues facing F Street, has been replaced with a stone monument.

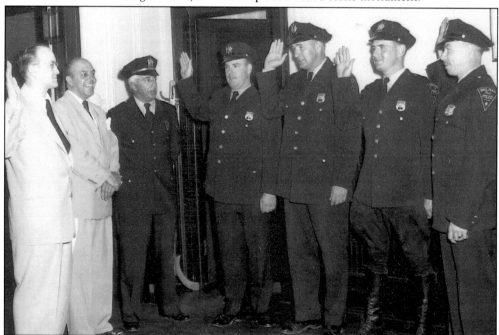

In this 1949 photograph, new police officers are sworn in. Pictured, from left to right, are Harold Feinberg, Mayor Peter Maclearie, Police Chief Al Isola, Bob Brand, Ernie Davenport, Bob Pringle, and Philip "Rip" Burger. Notice the pants and boots that Bob Pringle is wearing for motorcycle riding. (Bob Brand.)

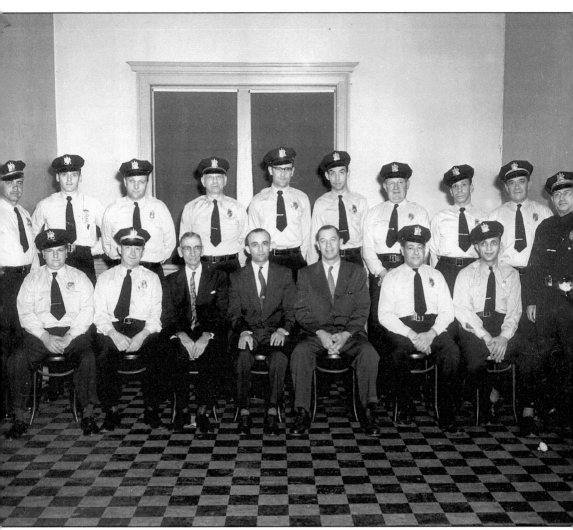

"Always on call and ready to serve" could be the motto of the Belmar Police Reserves. At the time this picture was taken, c. 1955, Belmar reservists were a very active part of the police department, especially with the influx of the summer residents. During the 1950s, all police reservists were certified to carry weapons and had responsibilities similar to the full-time police officers. The role of the reservists has changed in the last 40 years. Specials, as they are now called, are classified as class 1 or class 2. Class 1 specials are basic crossing guards, who also write tickets but are not certified to carry weapons. Class 2 specials undergo several months of police training, carry weapons, and have arrest powers. Pictured here, from left to right, are the following: (front row) William Morton, Dennis Hayes, Civil Defense Director Harry Cooper, Commissioner John Taylor, Police Liaison Patrolman Spencer Clawson, Irving Granoff, and Aaron Maketansky; (back row) George Rochkovsky, W.J. Byrne Jr., Raoul Cordeaux, Walter Litowinsky, William Gurinnup, Ernest Keller, Stan Welker, Arthur Cavanaugh, and Harry Goldwin. Coauthor Sandra Epstein's father is Irving Granoff. This photograph is courtesy of his wife, Theodora Granoff.

Who is that cowboy? Although this actor is not riding the range here, we know that he is visiting Belmar *c.* 1948, the date of this Steele's Photographic Service photograph. We also know that his first name is Rod, but nobody seems to remember his last name. People look at him and say that the face is so familiar! The general opinion is that this man played cowboy roles. The two women and the girl are also unidentified.

Jimmy Moyer, whose family owned Moyer's Pharmacy in Belmar, worked behind the soda fountain counter at the store. However, he was best known for the way he could make the ivories "dance" when he sat down at the piano. His teacher, Miss Dillon, was the organist at a local church, and he, in turn, also gave piano lessons to many Belmarians over the years. (Steele's Photographic Service.)

This amusing photograph appeared in *The Coast Advertiser* on Thursday, January 29, 1953, with the following caption: "Members of Belmar Woman's Club Kitchen Band rehearse a number for their first public appearance (outside of club meetings) in "Variety Show," to be presented February 13 at Belmar Grammar School Auditorium. The instruments in the band include pots, pans, boiler, bedspring, washboard, mop, and feather duster. Mrs. Thomas Purcell, show director and leader of the band, presides at the piano, while Mrs. Donald Matthews adds sweetness to the music with her violin. Left to right, front row, Mrs. F. William Nuffort, Mrs. Elmer Desmond [see note at end of this caption], Mrs. Cecil Lear and Mrs. August Regan; standing, Mrs. Matthews, Mrs. Albert Hartung, Mrs. Louise Heyniger, Mrs. Charles Frantzen, Mrs. Purcell, Mrs. Charles Schneider, Mrs. Stephen J. Lacko, Miss Jean Howlett, Mrs. Harold Bryan and Mrs. Oscar Teske. Belmar Camera Shop Photograph." The Belmar Woman's Club started in 1914 and continues today as an active and well-respected organization that does much for the community. Mrs. Elmer Desmond, playing the bedsprings—errr . . . harp, shall we say—is one of Belmar's most well-loved citizens. She is Mildred Desmond Day, the lender of this photograph. Coauthor Karen Schnitzspahn met Mildred in the early stages of working on *Belmar, Volume I* and truly enjoys their friendship.

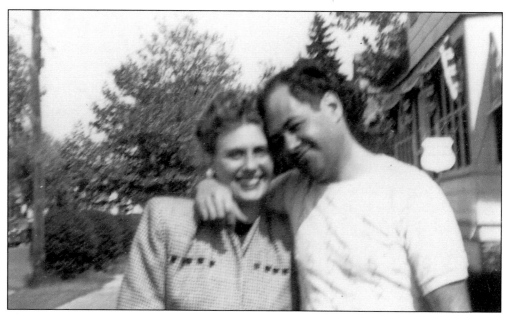

Their smiles tell it all. Theodora "Teddy" Granoff and Irving Granoff take a moment to smile for the camera. The Granoffs, parents of coauthor Sandra G. Epstein, moved the family to Belmar in 1944 and spent many happy years living at 301 Eleventh Avenue. Irving, the proprietor of the Tenth Avenue Pavilion, now the Howard Rowland Pavilion, also worked as a special police officer during the summers. By the looks of their clothing in this 1940s photograph, Teddy is ready for a day out, but Irving is dressed casually for a day at home.

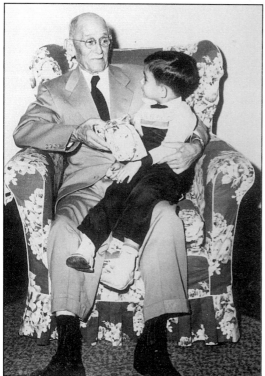

In 1951, Paul C. Taylor sits in a comfortable chair with young John Osler on his knee. The owner of Taylor's hardware and department store, Paul was mayor of Belmar from 1905 to 1906. His son, John A. Taylor, for whom today's Taylor Pavilion at Fifth Avenue is named, was mayor of the borough from 1967 to 1979.

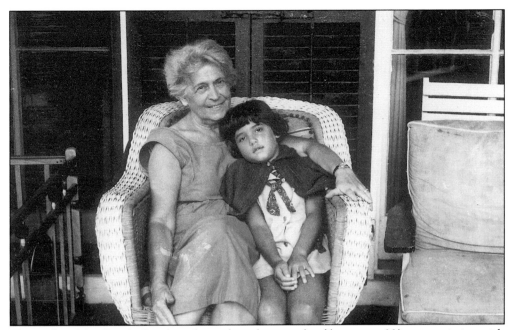

The ageless Mae Bonda Fox (see the earlier photograph of her on p. 22) enjoys sitting with Mindy Estelle Fox, one of her nine grandchildren, c. 1965. They are on a verandah of the Fox summer home at 100 First Avenue, where four generations of the family enjoyed carefree summers. Although Mindy looks a bit wistful in this portrait, she is known to have had great fun in Belmar and still spends her summers at the Jersey Shore. (Arthur C. Fox.)

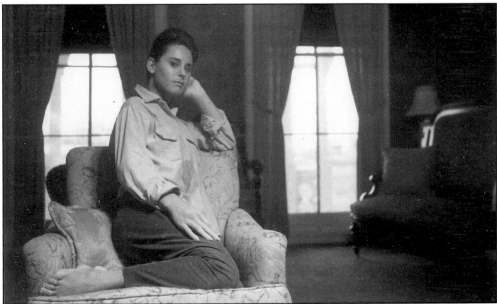

This artistic black-and-white portrait of Esther Fox, wife of David I. Fox, was taken in the early 1960s in the living room of the Fox summer home, at 100 First Avenue. The portrait reveals the floor-to-ceiling windows of the 1880s house. The living room, often used for special occasions and family celebrations, had a splendid red brick fireplace. The two-story, verandah-style house no longer stands, but the family's fond memories of times spent there endure. (Arthur C. Fox.)

90th
Birthday Celebration

John Ferruggiaro

Barclay Hotel
Belmar, N.J.

The program cover for John Ferruggiaro's 90th birthday celebration, given by his family at the Barclay Hotel on March 5, 1994, shows the smiling face of the late borough commissioner, who died in 1998. John, who grew up in Belmar, was known to be "a sincere, honest, and conscientious official" and was well-liked in the community. Many people say that he looks a bit like George Burns in this photograph. (Lois Gallagher.)

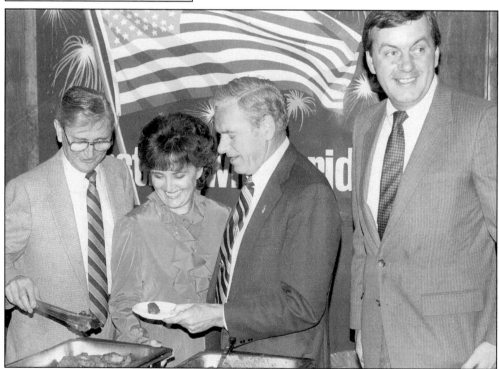

Enjoying a buffet at a campaign party c. 1988 are, from left to right, Fran Pyanoe (mayor from 1979 to 1987), Mayor Maria Hernandez, Congressman James J. Howard, and Commissioner Paul Caverly. (P. McCann.)

All dressed up for the wearing o' the green are Lois and Andrew Gallagher and their daughter Natalie (now Hurley). Andrew is currently a Belmar councilman. The three are ready for the very first Belmar St. Patrick's Day parade in March 1973. (Lois Gallagher.)

This March 1999 photograph taken on F Street at Ninth Avenue shows St. Patrick's Day parade chairman Dave Stanley greeting the drum major of one of the traditional piper bands that march in Belmar's annual event—one of the largest, if not *the* largest, St. Patrick's Day parades in New Jersey. (David Stanley.)

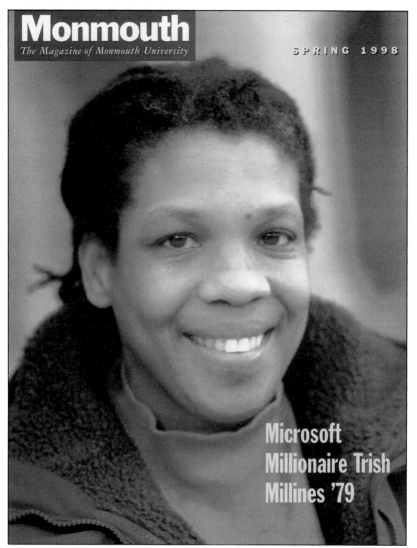

Monmouth
The Magazine of Monmouth University

SPRING 1998

Microsoft
Millionaire Trish
Millines '79

Trish Millines, a "Microsoft millionaire," is featured on this cover of the spring 1998 issue of *Monmouth* magazine. Trish grew up on Eighteenth Avenue and went to Belmar Grammar School, where she graduated from eighth grade in 1971. Her mother, Patricia Ann Millines, did cleaning for a living and was a single parent. She died when Trish was 17 but first made sure her only child realized the importance of a good education. Trish, an excellent student and star basketball player at Asbury Park High School, was awarded a basketball scholarship to Monmouth College in West Long Branch, New Jersey, now Monmouth University. She was the Hawks' starting point guard from 1975 to 1979. She graduated from Monmouth in 1979 and began to seek a job in the computer industry. She headed west and ended up in Seattle in the mid-1980s. In 1990, she joined Microsoft, a company she had done some consulting for. The company run by Bill Gates was a phenomenal success, and by 1996 Trish was able to retire. Her philanthropic objective became "to introduce technology to low-income teens so they can enter the job 'pipeline' with the skills to compete successfully." She is currently the executive director of the Technology Access Foundation, which helps inner-city teens. (Cover reprinted with permission of Monmouth University and Trish Millines.)

Seven

SILVER LAKE AND GOLDEN MEMORIES

Postcards with scenes surrounded by seashell borders were popular in the early years of the 20th century and are desirable items for collectors today. This graceful c. 1908 view is an artist's depiction of Silver Lake, which lies entirely within the boundaries of the borough. Before the organization of Ocean Beach in 1872, Silver Lake was called West's Pond.

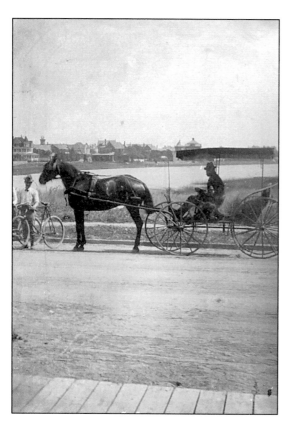

This rare image is a tintype c. 1890s of Jacob Kasdan in the horse-drawn wagon by the east end, or ocean side, of Silver Lake. The boardwalk is visible in the front of photograph, and houses on Sixth Avenue can be seen in the distance. Notice that Ocean Avenue is a dirt road. (Claire Kasdan Angrist.)

A postcard from the Arthur Livingston Picturesque America series, c. 1905, shows a view of Silver Lake that is very similar to the scene with seashell motif on the previous page. (John F. Rhody.)

Official Program

FOURTH ANNUAL

BELMAR CARNIVAL

TO BE HELD

Saturday Afternoon and Evening, August 27, 1910, Weather Permitting

OFFICERS OF THE BELMAR CARNIVAL ASSOCIATION

Chairman, Asher Lambert Secretary, L. S. Lancon Treasurer, Robert G. Poole

Chairman of Finance, Dr. Hassler Manager, S. W. Combs

AFTERNOON—Order of Sports

For All Entries See Mr. Donald McGregor, 203 Seventh Avenue, Belmar. Close Thursday Evening, Aug. 25

Sports on Land and Lake Start at 3.30 P. M. Sharp

THE FOLLOWING ARE EVENTS IN ORDER:

WINNER

1 Boys' Bike Race, Under 12 . . .
2 Boys' Bike Race, Under 16 . . .
3 Single Flat-Bottom Boats, Boys under 16
4 Single Flat-Bottom Boats, Men .
5 Mixed Double Canoes
6 Double Flat-Bottom Boats, Boys under 16
7 Single Canoes, Men
8 Single Flat-Bottom Boats, Ladies
9 Double Canoes, Men
10 Mixed Double Flat-Bottom Boats
11 Men's Double Flat-Bottom Boats
12 Canoe Tilting, Boys
13 Canoe Tilting, Men
14 Tub Race, Boys
15 Tub Race, Girls

Bike Races will be first—Other events may be run in a different order—Boat Parade to close the day.

Sport Prizes Will Be Given Out by Mr. McGregor, 203 Seventh Avenue, Day of Carnival

AFTERNOON—Order of Program

Parade starts at 2.30 P. M. sharp in the following order:

WINNER

Belmar Police Department |
Prof. Volo's Band |
Belmar Fire Department |
Decorated Automobiles |
Decorated Carriages |

Line of March will be as follows:
Form on Sixteenth Avenue, right resting on Ocean Avenue, Ocean Avenue to Sixth Avenue, around Lake to Ocean, Ocean Avenue to Second Avenue, Second Avenue to A Street, A Street to Fifth Avenue past reviewing stand in front of Chairman Lambert's house. After being judged parade will dismiss at Ocean and Fifth Avenues.

EVENING PROGRAM

Parade of decorated boats and floats at 5 P. M., boats forming for parade at West end of Silver Lake, moving at 5 P. M. eastward making one round of lake and back to judges stand. All boats and floats not ready at 4 P. M. will be disqualified.
Illumination, surface of Lake from 7.45 to 8.30.
Judging of decorated houses at 9 o'clock.
Grand display of fireworks at 8.30.
Music furnished by Prof. Volo's band, both afternoon and evening.
Prizes are now on exhibition at Gordon's and Sanborn's Pavilions.
Something doing all the time—It is your Carnival, help make it a success.

All boats and canoes that are entered for races must assemble in the enclosure at Sixth Avenue and A Street, south side of lake, to be designated by stake flags. Nobody permitted within twenty-five feet of the course.

All Entries Close with Donald McGregor, 203 7th Avenue, on Thursday Evening, August 25, 1910.

The Official Program for the fourth annual Belmar Carnival, held in 1910, lists events that included "sports on land and lake," an afternoon parade, and evening fireworks. The 1908 water festival is pictured on p. 122 of *Belmar, Volume I.* (Carolyn Larson.)

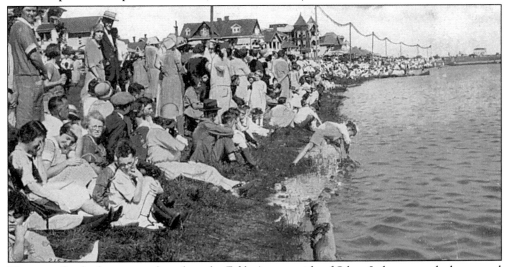

Throngs of onlookers are gathered on the Fifth Avenue side of Silver Lake to watch the annual water carnival. This postcard view, *c.* late 1920s, is looking east toward the Fifth Avenue Pavilion and the towers of the Brunswick Hotel.

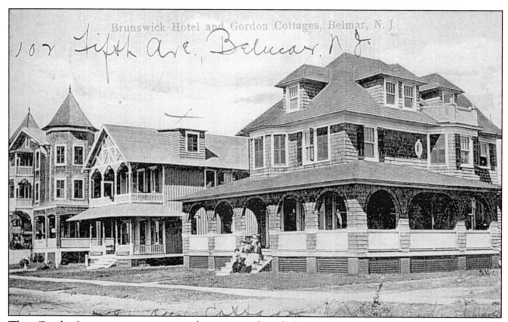

The Gordon's cottages were on the west side of Ocean Avenue, across from Gordon's Pavilion at Fifth Avenue. The Brunswick Hotel is visible on the far left of this photo postcard. (John F. Rhody.)

This photo postcard, c. 1920, shows houses on Sixth Avenue. Notice how the water of Silver Lake extends close to the street. This end of the lake was later filled in. (John F. Rhody.)

Although there is damage to this August 8, 1932 photograph, it is still a marvelous panoramic view of Silver Lake taken by Adams & Brown of Asbury Park, who did many such sweeping images of the shore area. Shown are houses along Sixth Avenue, the Fifth Avenue Pavilion, and the swan boats in the lake on the far left. A sign on the lamppost advertises parking for 25¢, but it appears that nobody wanted to pay. (Dennis Lewis.)

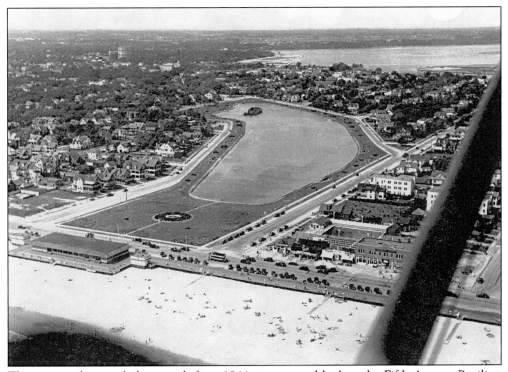

This spectacular aerial photograph from 1944 gives a good look at the Fifth Avenue Pavilion and beach, all of Silver Lake, and the Shark River Basin in the distance.

101

This linen-type postcard dated 1951 shows a bird's-eye view of the lovely flower beds at the Ocean Avenue end of Silver Lake, where the Huisman Gazebo now stands.

Posing behind the Angrist's house at 105 Sixth Avenue, c. 1940s, are the following, from left to right: (seated) Robert Kasdan and his daughter, Claire Kasdan Angrist; (standing) Claire's sister, Sylvia Kasdan Angrist (the two sisters married two brothers!), and their father-in-law, Isaac Angrist. (Claire Kasdan Angrist.)

This page is in tribute to Claire Kasdan Angrist (1909–1998). Claire so enjoyed her view of Silver Lake! She and her husband, Charles King Angrist, spent summers from 1933 to 1937 in a rental cottage on Eighth Avenue. They then moved to 105 Sixth Avenue on the south side of Silver Lake, which became their year-round home in 1944. Mr. and Mrs. Charles Angrist had two children, Nancy (now Myers) and Eugene. Charles died in 1991 and Claire continued to live at the Sixth Avenue home. (Claire's relatives, the Kasdans, are depicted in chapter six of *Belmar, Volume I* and chapter seven of this volume.) This lovely studio portrait of Claire from the 1950s is truly the image of the teacher everyone wishes they could have had. She taught English at Asbury Park High School for many years, retiring in 1973. "I am grateful to Claire Angrist for her friendship and kindness. How lucky I was to meet her while I was working on *Belmar, Volume I*. I would often stop by and relax on her porch, while chatting with her . . . and her dog Munchkin! Those were cherished times that I shall always remember."

—*Karen L. Schnitzspahn*

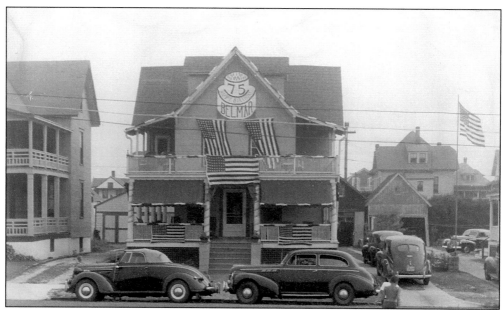

The Angrist home at 105 Sixth Avenue is all decked out, as many houses were, for Belmar's festive 75th anniversary celebration in 1947. (Claire Kasdan Angrist.)

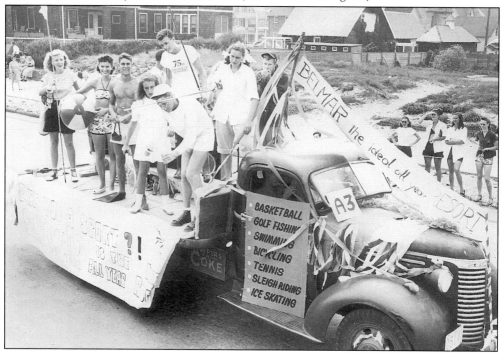

The local young people in this photograph of Belmar's 75th anniversary parade in August 1947 are having a grand time. Their float is on a truck borrowed from Ed Broege. It honors a variety of recreational sports played at Belmar and promotes year-round activities. The revelers in the photograph are, from left to right, Isabel Leach, Shirley Daniel, Don Thixton, Barbara Walters Traverso, Bruce Martin, Lorraine Bonk, Cecil Lear, and John Mayer (in a 75th anniversary shirt). (Cecil Lear.)

Eight

UP AND DOWN
THE SHARK RIVER

In the late 1880s, some young men strike a casual pose for a photographer near Buhler's Pavilion, in the area that is now the Belmar Marine Basin on the Shark River, at the foot of Tenth Avenue. (More images of Buhler's are featured in *Belmar, Volume I*, chapters one and five.) (The Fisherman's Den.)

"Moo" was a sound heard frequently along the banks of the Shark River in the late 19th century. Cows could still be seen grazing in Belmar well into the 20th century. (The Fisherman's Den.)

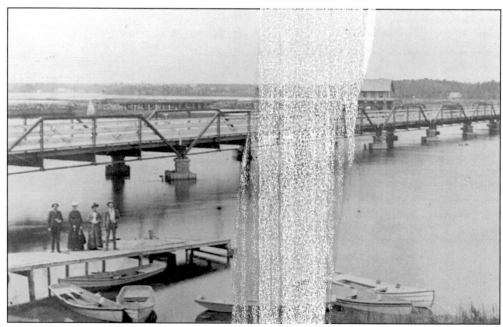

This 1880s view of the original F Street Bridge over the Shark River reflects a very different atmosphere from today's bridges, which handle a high volume of traffic. A Mr. Young and his family stand on a small pier near the bridge. (The Fisherman's Den.)

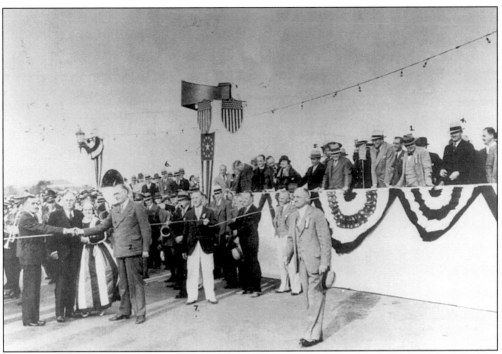

A festive celebration inaugurated the new F Street bridge across the Shark River in 1936. Some of the well-known people attending included Mayor Thomas S. Dillon, freeholder Joseph Mayer, E. Donald Sterner, state senator Frank Durand, Raymond L. Wyckoff, Leon T. Abbott, and Ernest C. Blaicker. This photograph is from the *Monmouth Pictorial*. (Robert A. Schoeffling.)

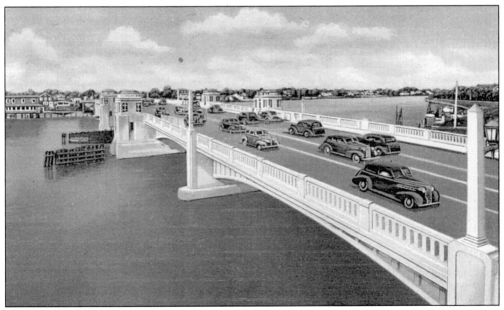

A classic 1940s linen postcard glorifies the Sterner Memorial Bridge over the Shark River, between Belmar and Avon.

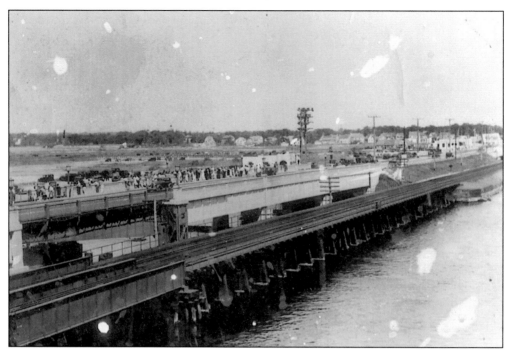

The opening of the Route 35 bridge was celebrated in grand style. While building the bridge in 1927, the skeleton of a whale and cannonballs dating to the Revolutionary War were found on the site. In this 1928 picture, cows can be seen grazing in the distance. Route 35 was once known as Route 4 and led into Highway 35. (Klein's Fish Market.)

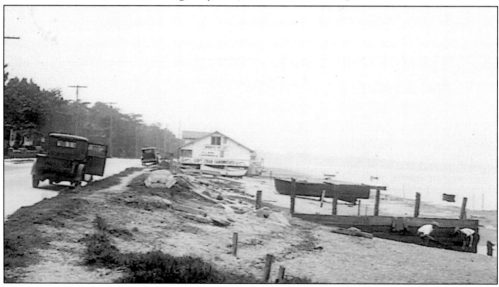

The area in this 1925 picture of River Road, looking west from Twelfth Avenue and H Street, is now known as the L Street beach. It appears that two men in a hurry to get to the water's edge left their car door open. Could they have a hankering for fresh clams? The unidentified building in the background advertises soft-shelled crab sandwiches, clam chowder, and boats for rent. This might have been a good place for fishermen to buy lunch to go, rent a boat, and enjoy the day. (Sterner's Lumber.)

This postcard, mailed in 1906, shows Bennett's boathouse on the left foreground. Visible in the distance in this view from the south bank of the Shark River is Buhler's Pavilion at the foot of Tenth Avenue.

Rental boats are tied up at the dock of Carpenter's Pavilion in this 1925 picture. The scene does not seem to have quite the same elegance as the picture from 1910, when it was Buhler's Pavilion (see *Belmar, Volume I*, p. 77). (Sterner's Lumber.)

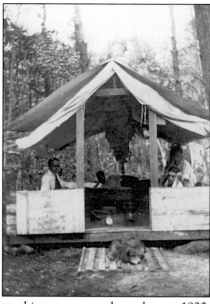

A summer tent belonging to the Lear family is transformed into a summer bungalow, c. 1920, at Rhode Island Point. First, we see the tent to which sides are added. (Note: this southwestern section of Belmar near the Shark River was annexed from Wall Township and officially became part of the borough of Belmar in 1927; see the frontispiece map in *Belmar, Volume I.*) (Cecil Lear.)

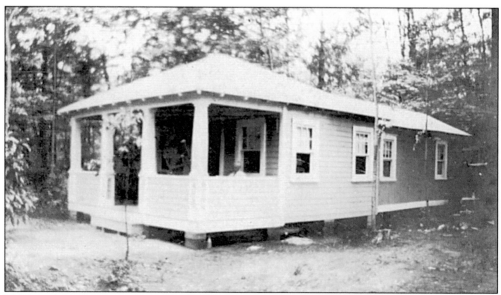

The Lear's summer retreat is seen here again going from tent to bungalow. This photograph shows the sections that were added in 1927 and 1928. The bungalow is now a year-round house in the 1200 block of Maplewood Drive. (Cecil Lear.)

Ann Tyrell Leedom and her husband, Ed, pose in front of their cottage on Seventeenth Avenue, c. 1920s. At one time residents lived in tents, which they later replaced with small cottages. Some of these still stand today. (Bruce Allen.)

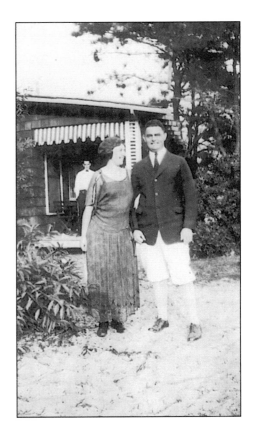

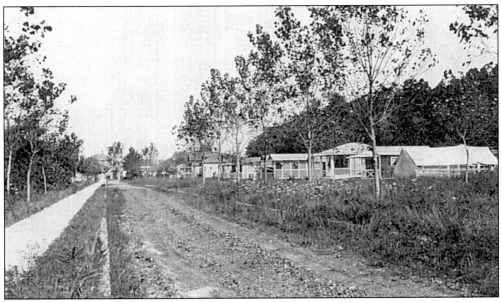

The photograph on this postcard of tent homes in the Rhode Island Point section is a rarely seen image. Although there is no date on the card, the scene is likely c. 1920. Many of these tents were converted into year-round homes. (John F. Rhody.)

This charming young woman on a swing is Mary Kennedy, great aunt of Bruce Allen, who loaned this c. 1924 photograph. She is in front of a cottage on Seventeenth Avenue.

Young Donald Collins steals the show from his grandparents as he sneaks into the picture while they are apparently unaware. Mary and Daniel Collins are reminiscent of the couple in the painting *American Gothic* in this delightful photograph taken at their Belmar bungalow on August 22, 1936, just a few days after their 50th wedding anniversary. They are the great-grandparents of Bruce Allen, who provided the photograph.

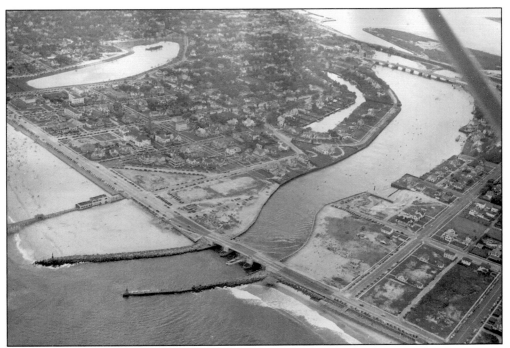

A wonderful 1940s aerial view of the Shark River Inlet, leading out to the ocean, was taken after the north jetty was extended. Sand had built up at least three times over several years, and dredges were used to haul it out. The jetty extension was built to solve the problem. (Cecil Lear.)

This 1936 picture taken from the bridge looking toward First Avenue shows a white Coast Guard motor surfboat on the left. The small white building near the water is the Coast Guard house. During Prohibition, the Coast Guard searched many of the boats because rumrunners were prevalent and ran a profitable, though illegal, business. (Sterner's Lumber.)

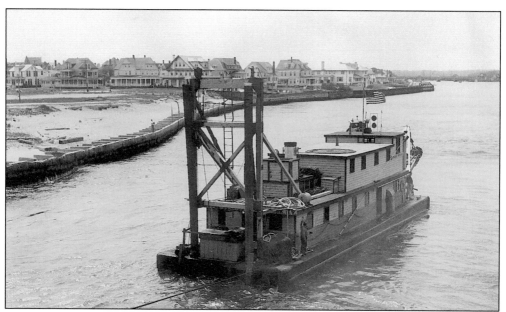

Working like a vacuum, this dredge does its job in the Shark River Inlet in 1947. The inlet started to shoal over, forming a sandbar. Because it was a problem for the party boats, the captains formed a committee and had the Army Corps of Engineers bring in the dredge. The following year, 1948, the jetty was built to create a more permanent solution. The dredge is headed into Belmar from the ocean. On the right is the F Street bridge; on the left are the Inlet Terrace houses. (Steele's Photographic Service.)

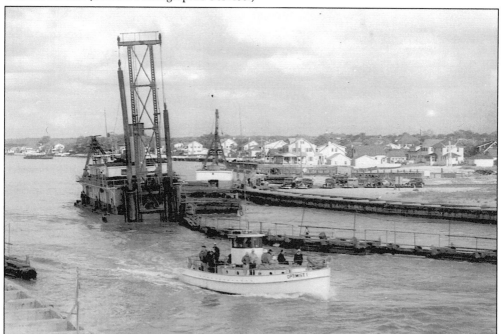

After a day of fishing, the *Optimist I* heads home to the Belmar Basin with Capt. Charlie Dodd at the helm. In the background, the dredge is pumping out the channel onto the Avon Beach. This picture was taken in 1936. (Sterner's Lumber.)

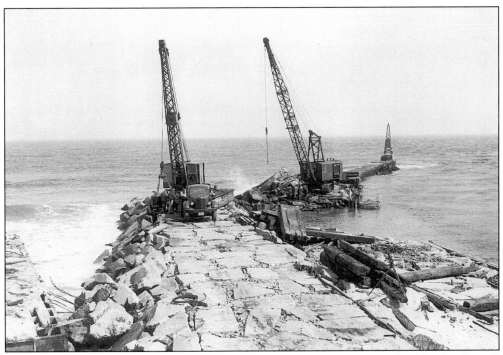

In 1948, the cranes are working their way toward the ocean, using very large boulders for the wall intended to protect the Shark River Inlet between Belmar and Avon. (Steele's Photographic Service.)

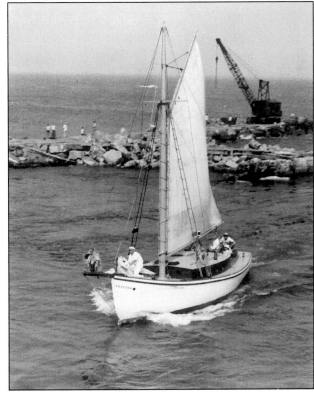

This catboat was the first boat to go through the inlet when it reopened in the mid-1940s. (Steele's Photographic Service.)

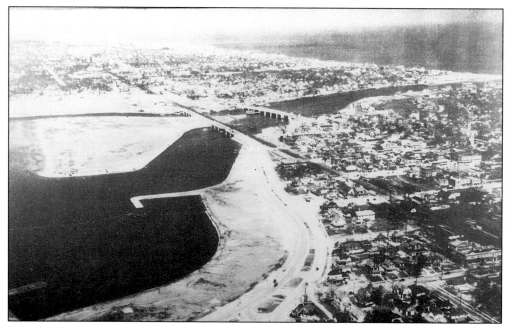

The caption for this aerial view from the *Monmouth Pictorial* spring/summer 1936 edition reads as follows: "A splendid view of the North Jersey Shore from Belmar toward Asbury Park showing beautiful highways No. 4N and 35 and Shark River Bridge which won the national pride in its class for excellence in design." (R.A. Schoeffling.)

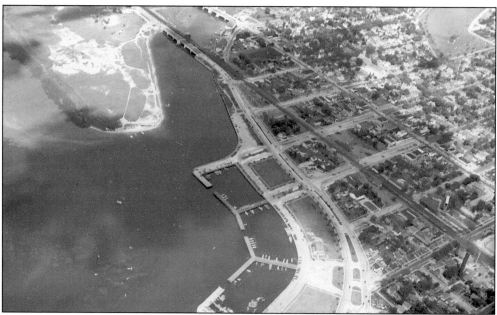

A clear aerial view gives a good picture of the newly finished Belmar Marine Basin, *c.* 1937–38. Compare this view with the one above in which the marine basin was filled in but not yet completed. (Cecil Lear.)

The proposed Amphibious Air Service in this late 1940s rendering never came to fruition. At one time, there was a seaplane landing in the Shark River, which took people looking for some excitement up for rides (note the insert of a seaplane). The reservation office can be seen in the picture below. (Steele's Photographic Service.)

This photograph of Ninth Avenue and the Shark River shows the intended location of the Amphibious Air Service. According to Capt. Charlie Dodd, the pile driver on the left belongs to Tom Proctor. (Steele's Photographic Service.)

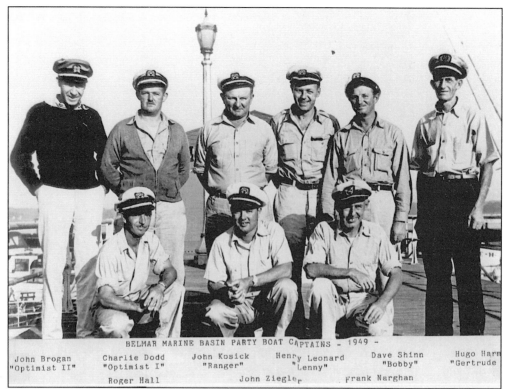

BELMAR MARINE BASIN PARTY BOAT CAPTAINS - 1949 -

John Brogan	Charlie Dodd	John Kosick	Henry Leonard	Dave Shinn	Hugo Harm
"Optimist II"	"Optimist I"	"Ranger"	"Lenny"	"Bobby"	"Gertrude
	Roger Hall		John Ziegler	Frank Narghan	

Charlie Dodd claims to have rented the first slip in the marine basin at Tenth Avenue for his boat *Optimist I*. Dave Shinn was second, with three boats. Posed for this 1949 group picture are all the captains who eventually docked their boats at the marina. (The Fisherman's Den.)

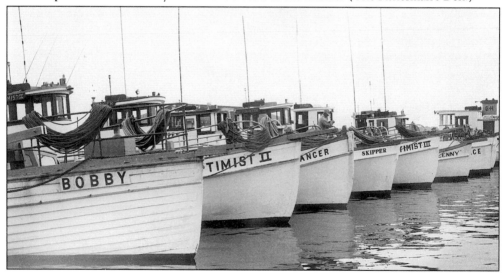

The Belmar Inlet, shown here with fishing boats tied to the dock, is Belmar's home base for charter boats, those that are chartered by groups, also known as head boats because they charge by the individual—by the head. The boats are no longer made with the wooden hulls shown in this *c*. 1950 picture. The third boat from the left is not really angry; the "R" is hidden, as the name of the boat is the *Ranger* rather than the *Anger*. (Steele's Photographic Service.)

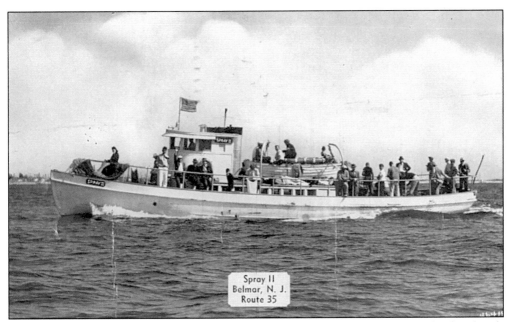

The *Spray II* is headed out for a day of mackerel fishing in this c. 1950 postcard. This diesel-powered boat was operated by Capt. Peter Saro.

Brian Epstein, night captain of the *Spray III*, c. 1986, proudly shows off his catch, a striped bass. Capt. John DeRose, the owner of the boat, ran it on day trips. (Brian Epstein.)

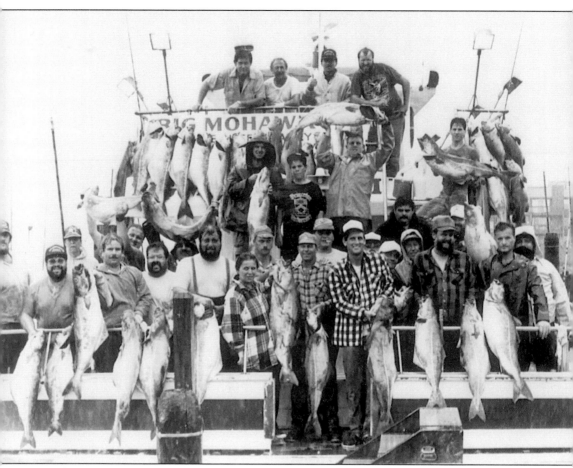

After a successful day of fishing on the head boat *Big Mohawk*, these fishermen and one fisherwoman are all smiles. The fishing boats at Belmar Marine Basin was not always used for pleasure alone. During World War II, according to Capt. Charlie Dodd, the federal government chartered the head boats for the sum of $1. The Coastal Picket Patrol, which included all Belmar head boats, was drafted and they patrolled 24 hours a day, 7 days a week, in search of German submarines. Fondly called the Hooligan Navy, they were organized by the Coast Guard in May 1942. The fleet consisted of auxiliary yachts and motor boats under 100 feet in length. Civilian boat owners were the boat skippers. (The Fisherman's Den.)

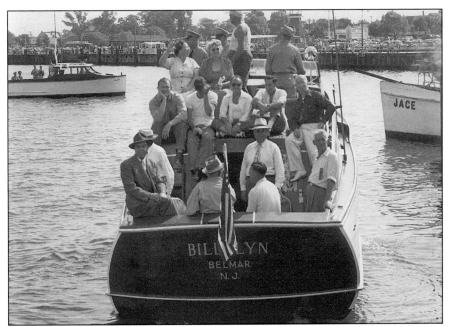

The committee boat for the annual U.S. Atlantic Tuna Tournament, the Gundaker family's *Billy Lyn*, heads out to sea with a full crew, c. 1950. Sitting on the left side of the stern, wearing his hat, is Mayor Peter Maclearie. On the right of the stern, with his back to the camera, is Commissioner John Ferruggiaro. Also on board are Pat and Sandy Breslin and several servicemen. The *Jace* (at right) is owned by Frank Narghan. (Steele's Photographic Service.)

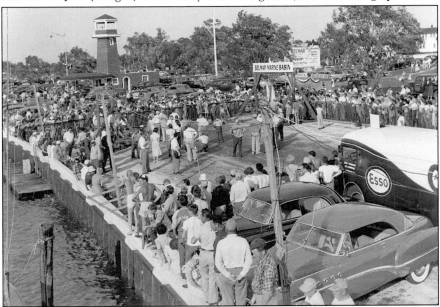

And the winner is . . .! The crowd anxiously awaits the name of the person who caught the largest tuna, which is visible hanging under the Belmar Marine Basin sign. Tuna tournaments were an annual event at the Belmar Marine Basin in the years after World War II through the 1950s, when they were discontinued. The tower in the background is the marina office. This c. 1947 picture was taken before the marina was rebuilt. (Steele's Photographic Service.)

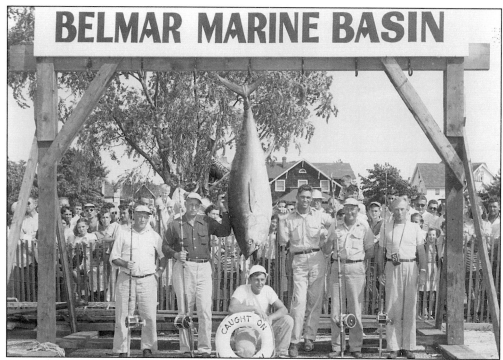

The captain and crew of the *Rainbow* pose with their tournament catch of the day. Does anyone recognize any of the people in the background? (Steele's Photographic Service.)

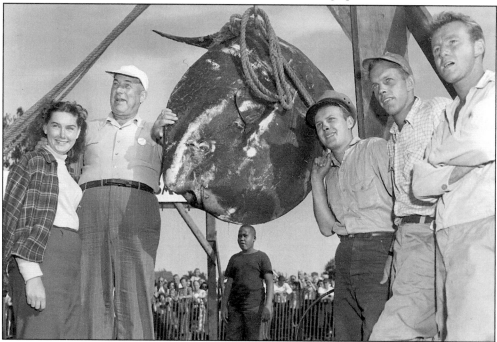

This fish does not quite look like a tuna because it is not a tuna—it is a sunfish. The sunfish is a harmless fish that has the ability to jump out of the water. In this *c.* 1950 picture, the fish appears to be balancing on the young man's head. (Steele's Photographic Service.)

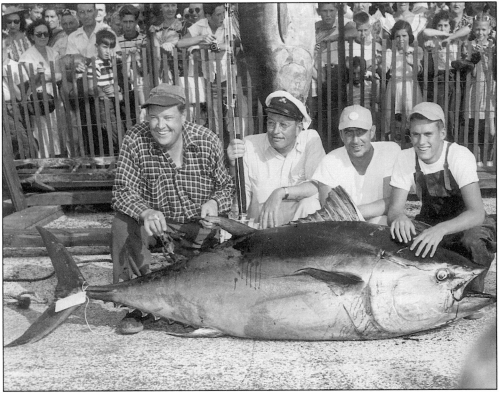

Could this be a winner? The tuna is tagged and smiles abound as four handsome men pose with the large fish. Freddy Shock is holding the fishing rod. (Steele's Photographic Service.)

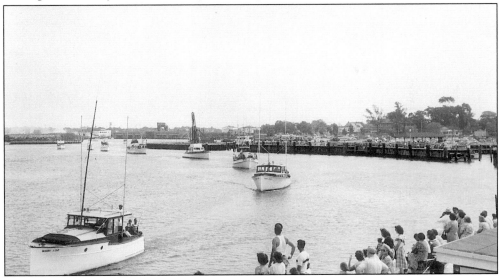

Spectators anxiously await the return of the fishing fleet. Leading the boats through the Shark River Inlet is the *Bobby Jane*, followed by the *Early Bird*. The white building in the left background is the Tides, originally built to help the rumrunners hide their cargo during Prohibition. To avoid getting caught, the rum would be stored in the building and hauled out by trucks, according to Capt. Charlie Dodd. (Steele's Photographic Service.)

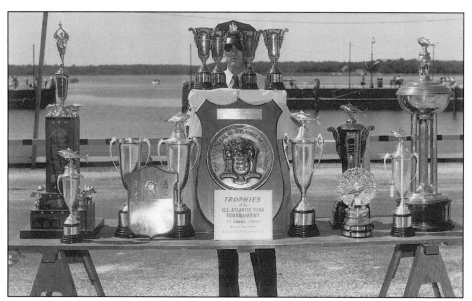

Does this table have an extra set of legs? No, the extra legs belong to Henry "Hank" McArdle of the police force, who is peeking through the trophies as he guards them during the seventh annual U.S. Atlantic Tuna Tournament. The trophies were on display at the Belmar Marine Basin for all to see before they were awarded to the winners. (Steele's Photographic Service.)

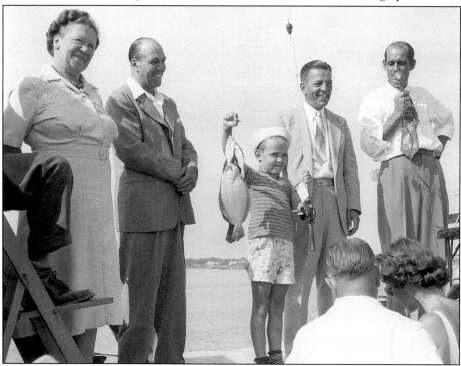

In the children's division, the young man in the center is proud to show off the prize fluke he caught off the dock. Standing, from left to right, are Sandy Breslin, Mayor Peter Maclearie, the unidentified winner, Commissioner John Ferruggiaro, and announcer Al Gor. (Steele's Photographic Service.)

Pat and Sandy Breslin, owners of Pat and Sandy's sandwich shop and boat rental business at the Belmar Marine Basin, received national recognition during World War II for offering servicemen free boating, fishing equipment, and refreshments. (Dick Napoliton.)

"THE FISHERMAN'S FRIEND'

SANDY

PAT and SANDY

BOATS

Bait Tackle

We're Still Hosts to Our Wounded Boys

BELMAR MARINE BASIN

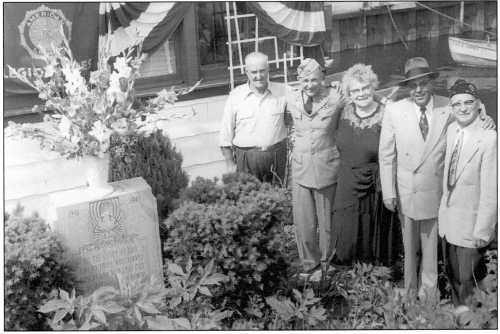

In 1949, Pat and Sandy Breslin erected a monument to honor those soldiers who visited the shop and later died in the war. In 1961, the monument was moved from the boat dock to Fort Monmouth. Shown in this 1955 photograph are, from left to right, Pat Breslin, an unidentified army officer, Sandy Breslin, Mayor Peter Maclearie, and a representative of the Catholic War Veterans. (Steele's Photographic Service.)

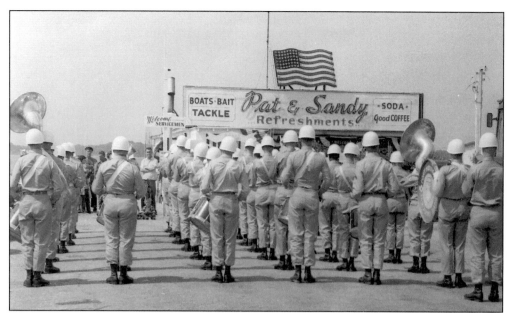

The Fort Monmouth Band performs in a Memorial Day celebration in 1955 at the Belmar Basin, in front of Pat & Sandy's. (Steele's Photographic Service.)

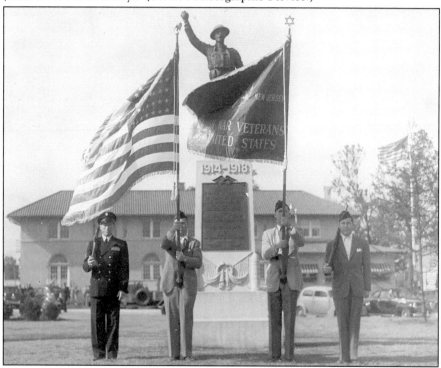

Members of the Jewish War Veterans stand at attention in front of the doughboy memorial honoring veterans of World War I. This c. 1949 picture shows, from left to right, Harry Goldwyn, two unidentified men, and Harold Jaffee at the memorial, which is located near the Shark River, across from the Belmar Municipal Building, now the Waterview Pavilion (see pp. 41 and 42). (Sari Goldwyn Raby.)

Every fisherman would love to take home a striped bass so heavy that it takes two men to hold it up. This photograph dates from the 1950s. (Steele's Photographic Service.)

What's for dinner? Before they fillet and cook a delicious meal, fishermen Ken Chizik (left), an unidentified man, and Johnny Byrnes (right) want to be sure that they have a "brag" picture to prove what they caught. The photograph, taken June 17, 1956, shows the catch of the day to be large fluke, also called doormats. (Steele's Photographic Service.)

In this vintage postcard view published by E.J. Seymour of Belmar, a lone collie prepares to "sail into the sunset" at the Shark River Marine Basin, providing a fitting close to this second volume about Belmar "by the beautiful sea" and the beautiful Shark River.

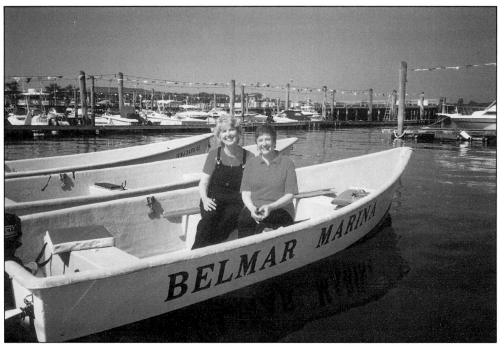

The coauthors of this book, Karen L. Schnitzspahn (left) and Sandra G. Epstein (right) are pictured here having fun at the Belmar Marina in 1999. "We wish peace and love to all readers of this book!"

—Karen and Sandra.